Henri

Matisse

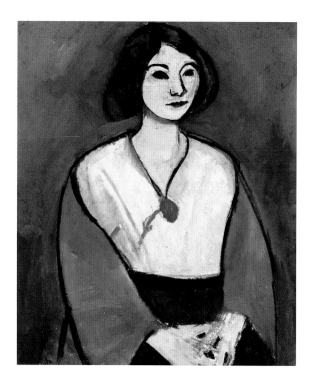

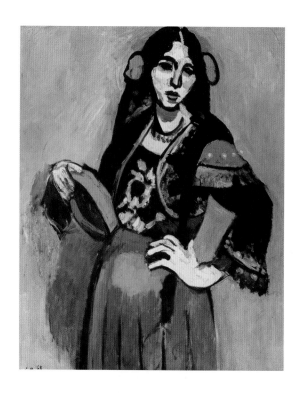

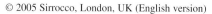

© 2005 Sirrocco, London, UK (English version)

© 2005 Confidential Concepts, worldwide, USA

© 2005 Estate Matisse / Artists Rights Society, New York, USA / Les Héritiers
Matisse

ISBN 1-84013-764-9

Published in 2005 by Grange Books
an imprint of Grange Book Plc
The Grange Kingsnorth Industrial Estate
Hoo, nr Rochester, Kent ME3 9ND
www.Grangebooks.co.uk

Printed in China

Henri

Matisse

Grange BOOKS

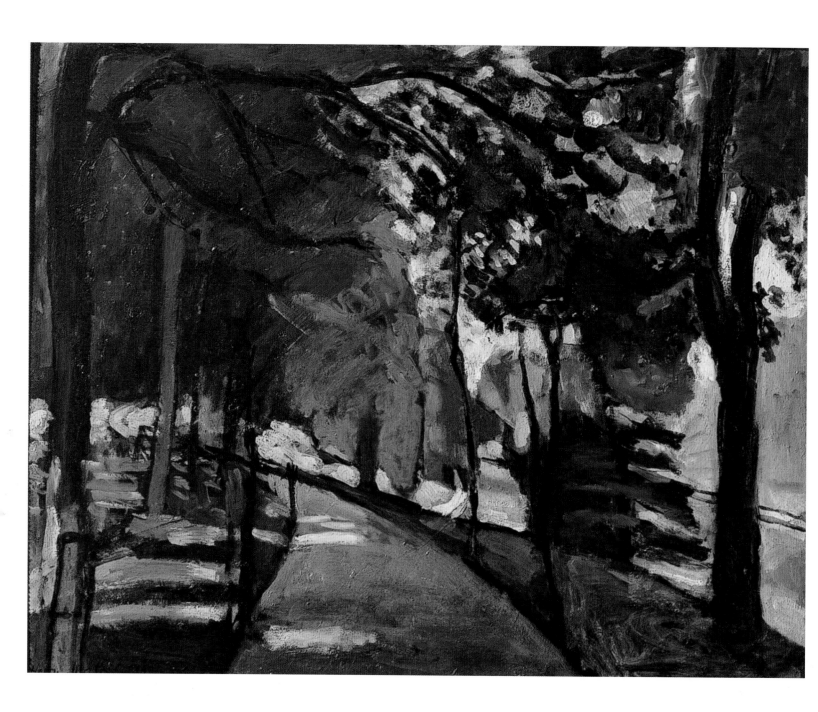

"Fauvism is when there is a red," said Henri Matisse concisely putting into words the most straightforward notion held of Fauvism. Matisse has in fact become fauvism's leader over the years as a result of his contemporaries and researchers persistently perpetuating such an idea. Consequently Matisse's œuvre has been scoured through in a search for the ultimate Fauvist painting. Matisse never pretended or aspired to such a role, and on the question of what Fauvism represents in theory and in practice, he never came to a final conclusion.

The "academic spirit" with which he was infused meant that his mind was always engaged in a profound and serious search for answers to the questions posed by the age in which he lived.

Matisse's pupils recollected that wholehearted respect for Ingres reigned in the Académie which he organized in 1908, while the art of Classical Antiquity was esteemed most of all. Matisse's character clearly favoured balance and order, that is to say Classicism in its most profound form, and it was probably because of this that Matisse became so enraptured by the studio which Maurice de Vlaminck and André Derain established. The "Chatou School's" use of primary colours proved to be the vital balancing which helped the young avant-garde to attain full artistic expression. For Professor Gustave Moreau's diligent pupil, as Matisse may be described, it was the discovery of Van Gogh at an exhibition in 1901; of Muslim art at an exhibition in Paris in 1903 and of the French Renaissance at an exhibition in the Grand Palais in 1904, that proved to be the crucial elements which shaped his artistic individuality. With the other Fauvists it can be argued that their art was dominated by either reason or emotion. Matisse's intellect, however, continuously searched for a direction where both reason and emotion became reconciled and balance and order might be found. At the 1905 Salon d'Automne critics were enraged by the anarchistic colour of his *Portrait of Mine Matisse in a Hat* (1905, private collection, San Francisco). Yet André Gide's famous remark about the rationalism of Matisse's group was inspired by that and other similar works.

In his essays and many writings, Matisse never attempted to define a concept of Fauvism. What he did do in fact was to concentrate his inquiring mind on Fauvism's actual sources. "Fauvism arose as a result of our determined rejection of false colour. As a consequence of this we achieved results with colour which were at once stronger and more noticeable. And then there was the luminosity of the colours as well." What Fauvism really represented for Matisse was a rolling into one of the varied creative impulses which saw Vlaminck and Derain painting the banks of the Seine using only red or blue, whilst simultaneously Kees van Dongen was colourfully filling in the contours of a dancer's expressively outlined body and Marquet was using delicate daubs of silver to unite water and sky.

1. *Bois de Boulogne*, 1902. Oil on canvas, 65 x 81.5 cm. Pushkin Museum of Fine Arts, Moscow.

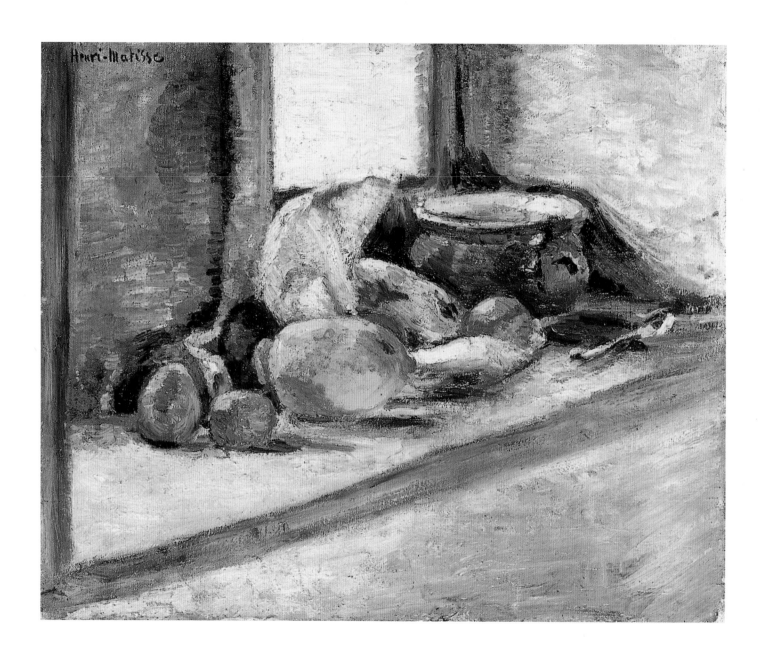

2. *Blue pot and lemon*,
 c. 1897. Oil on canvas,
 39 x 46.5 cm.
 The State Hermitage,
 Saint-Petersburg.

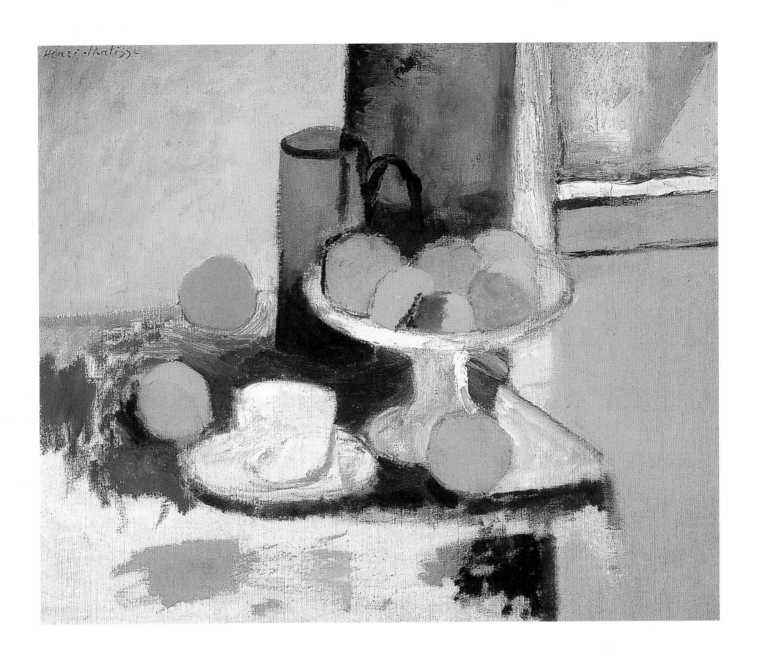

3. *Still Life with Oranges (II)*, 1899. Oil on canvas, 46.7 x 55.2 cm. Washington University of Art, St. Louis.

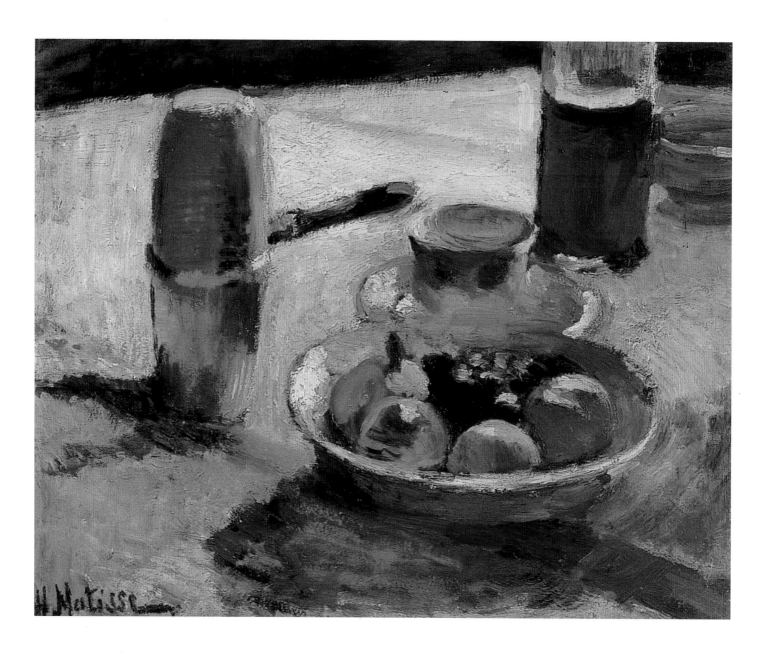

4. *Fruit and Coffee-Pot*,
 1899. Oil on canvas,
 38.5 x 46.5 cm.
 The State Hermitage,
 Saint-Petersburg.

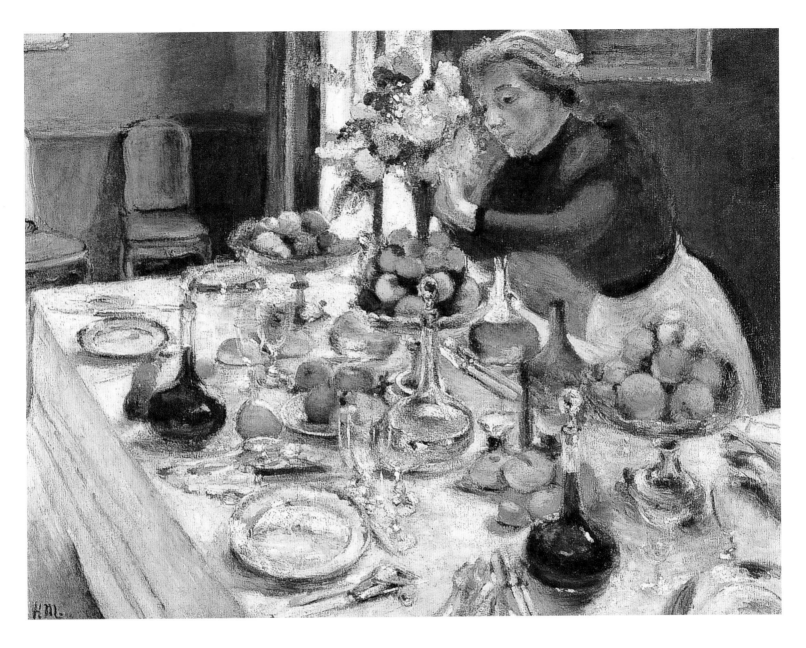

5. *La Desserte (Dinner Table)*, 1896-1897. Oil on canvas, 100 x 131 cm. Private collection.

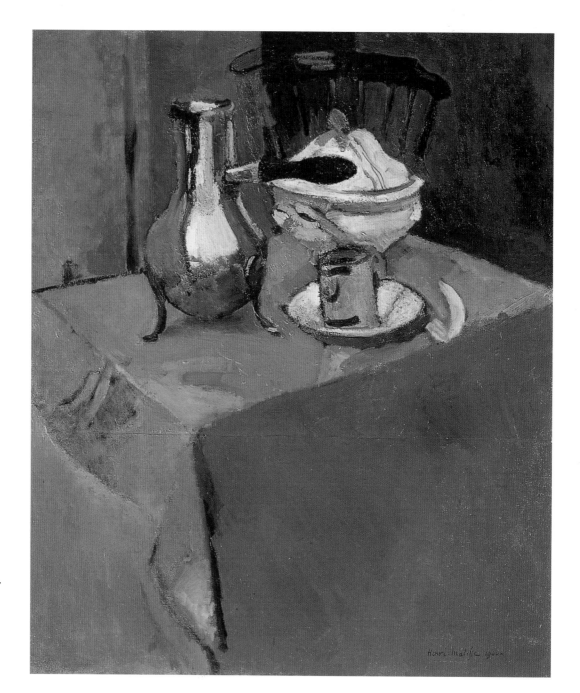

6. *Crockery on a Table*,
1900. Oil on canvas,
97 x 82 cm.
The State Hermitage,
Saint-Petersburg.

7. *Dishes and fruit,* 1901.
Oil on canvas,
51 x 61.5 cm.
The State Hermitage,
Saint-Petersburg.

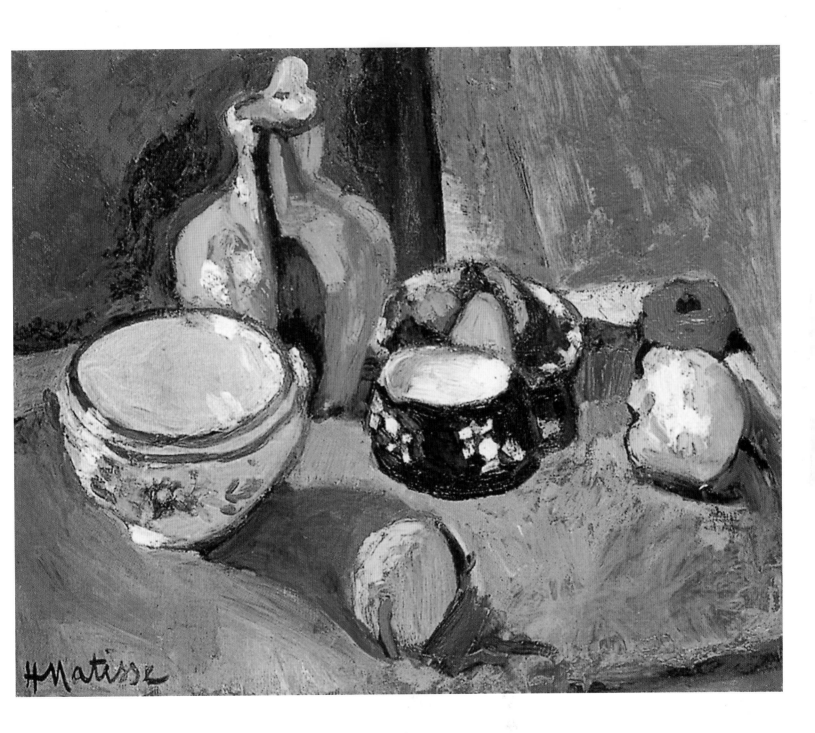

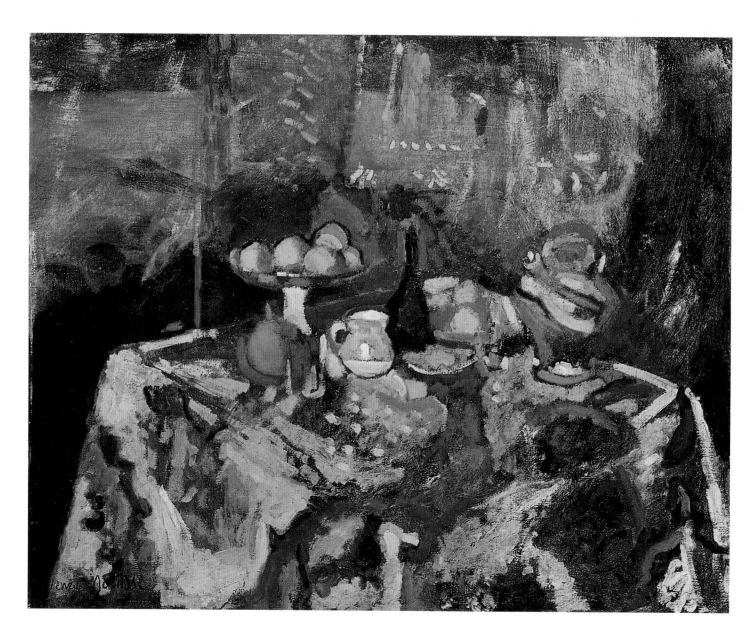

8. *Still Life with Vase,*
 Bottle and Fruit,
 1905-1906.
 Oil on canvas,
 73 x 92 cm.
 The State Hermitage,
 Saint-Petersburg.

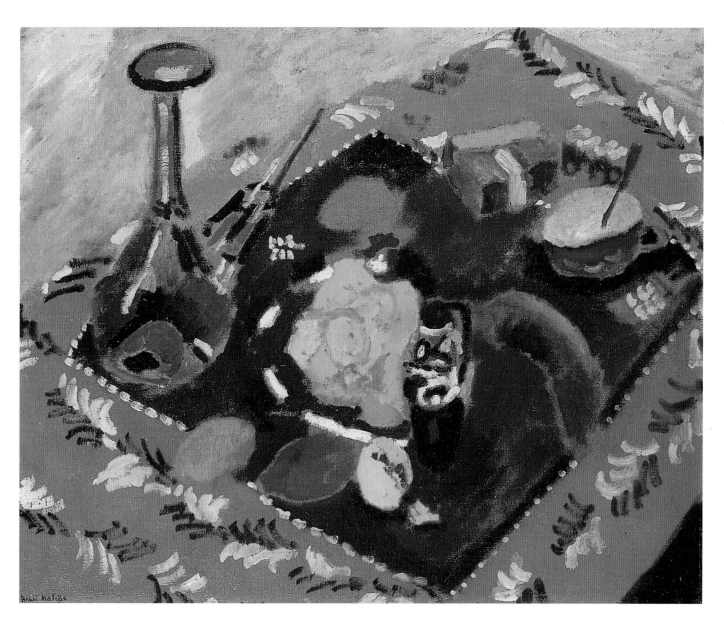

9. *Dishes and Fruit on a Red and Black Carpet*, 1906. Oil on canvas, 61 x 73 cm. The State Hermitage, Saint-Petersburg.

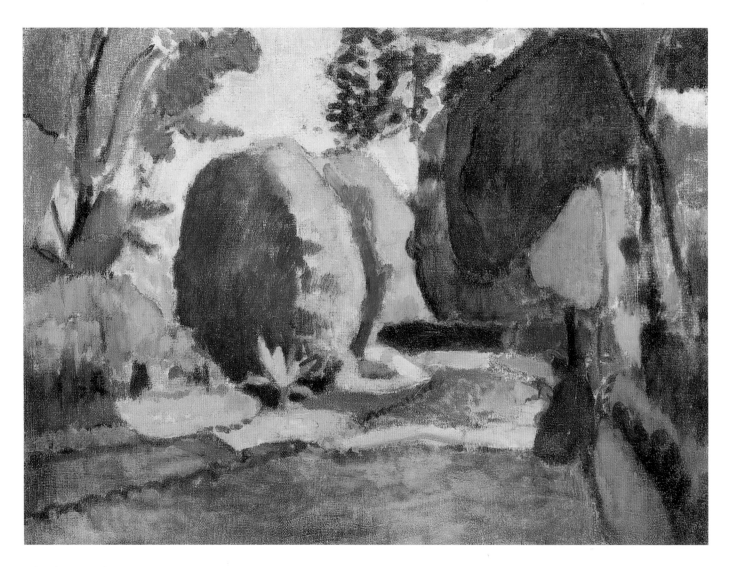

10. *The Luxembourg
 Gardens*, c. 1901.
 Oil on canvas,
 59.5 x 81.5 cm.
 The State Hermitage,
 Saint-Petersburg.

11. *Interior at Collioure,*
 1905. Oil on canvas,
 70.4 x 45.7 cm.
 Private collection.

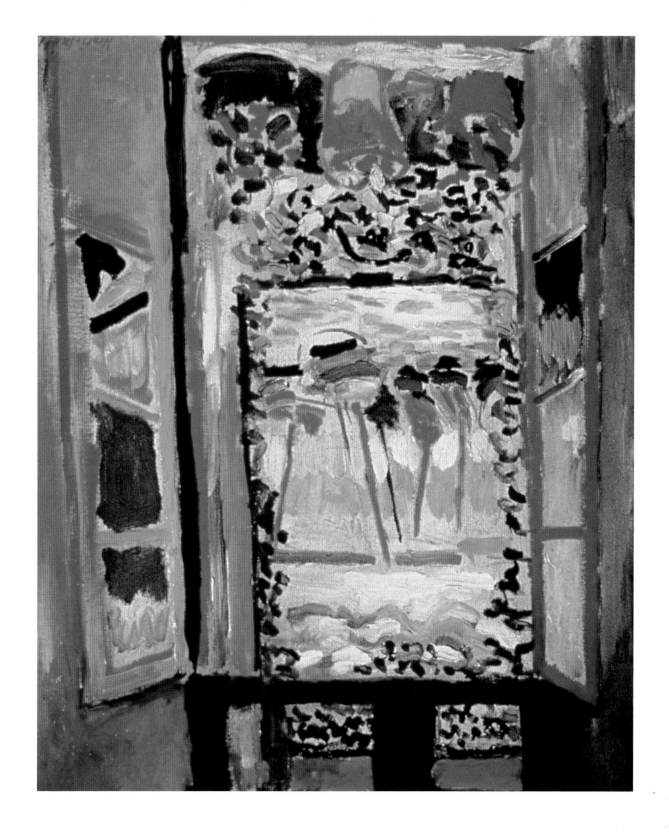

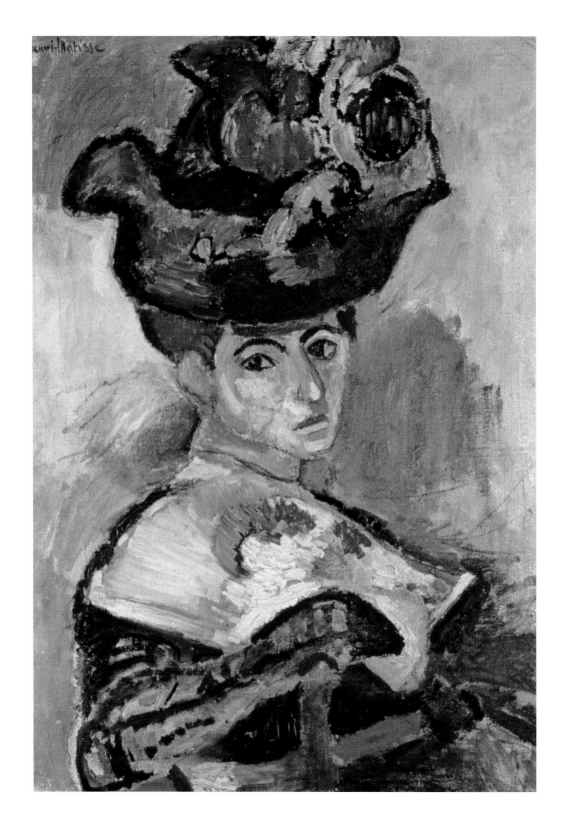

Matisse's art was never an ultimate expression of Fauvism. The Fauvist movement was the combined work of a number of artists with wide-ranging creative impulses who united around a certain core of precepts. The most important of these was freedom of expression.

If Matisse was not, as has been claimed, Fauvism's leader, then he was without doubt its "elder statesman". He was older and more sensible than the other members. His solid and positive character inspired respect and, unlike Vlaminck, he did not claim to be Fauvism's premier exponent. But he supported the concept of independence which united the Fauvists.

Henri Matisse was born on 31 December 1869 into a stallholder's family in Cateau-Cambrésis in northern France. He began his education at the lycée in Saint-Quentin and continued at Paris University where he read law. On graduating he returned to Saint-Quentin where he worked in a lawyer's office. During this period Matisse began to attend his first drawing classes and at the age of twenty, when an illness confined him to bed for nearly a year, he painted his first work.

Returning to Paris in 1891 Matisse started to take lessons at the Académie Julian, working as a law tutor to help pay his way. In 1892 he abandoned Bouguereau's totally uninspiring lessons and transferred to Gustave Moreau's classes at the Ecole des Beaux-Arts. During the evenings Matisse also attended classes in applied art and there he made friends with Albert Marquet, who soon also became a pupil of Moreau. It was at these classes that a group of artists came together and formed friendships that would endure all the trials and tribulations of their respective lives. This group consisted of the "Three M's" — Matisse, Marquet and Manguin; Georges Rouault, Charles Camoin and Louis Valtat. Working in Léon Bonnat's studio, which was just across the corridor, was another future member, Othon Friesz. And he would later be joined by Raoul Dufy.

From 1896 onwards Matisse not only began to exhibit his work in official salons, but he also became a member of the Société Nationale des Beaux-Arts. He was interested in the Impressionists and he also began to travel, going to Brittany and even as far south as Corsica. At this time too he married and started a family. After Moreau's death Matisse briefly attended Professor Ferdinand Cormon's classes, before joining Eugène Carrière Académie, where in 1901 he became friends with Jean Puy and Andre Derain. It was Derain who brought Matisse and Vlaminck together at the Van Gogh exhibition in 1901.

Matisse saw the twentieth century in as a father of three young children, a man in poor financial straits, an artist who had made only a limited name for himself, but nonetheless a highly respected member of the circle of artists in which he moved.

In 1901 Matisse and his friends started to exhibit their work at the Salon des Indépendants and in Berthe Weill's gallery. In 1903 they were involved in the founding of the Salon d'Automne, where two years later Vauxcelles would see their work and dub them "les fauves".

12. *Woman with the Hat*, 1905. Oil on canvas, 81.9 x 60.3 cm. San Francisco Museum of Modern Art, San Francisco.

13. *Luxury, Calm and
Delight,* 1904-1905.
Oil on canvas,
94 x 116.8 cm.
Musée d'Orsay, Paris.

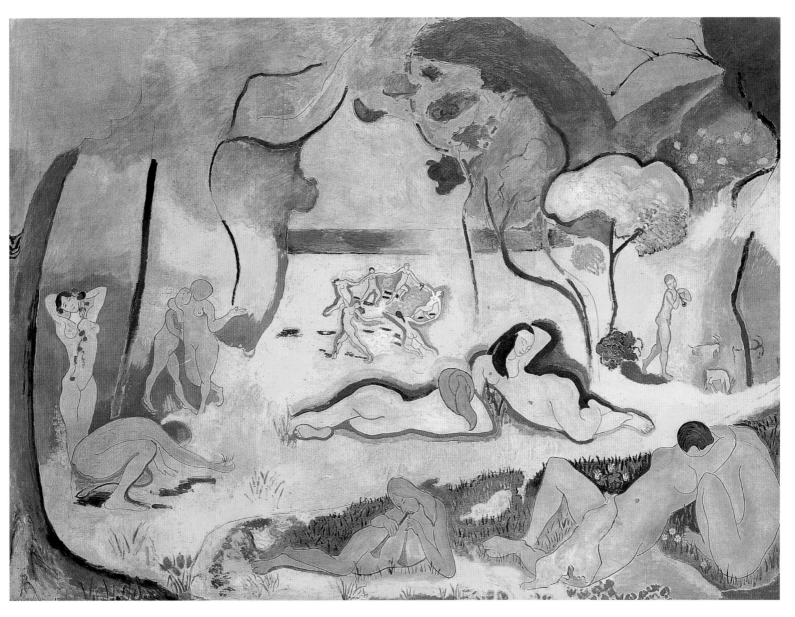

14. *Joy of Life*, 1905-
1906. Oil on canvas,
175 x 241 cm.
The Barnes
Foundation,
Merion, Pennsylvania.

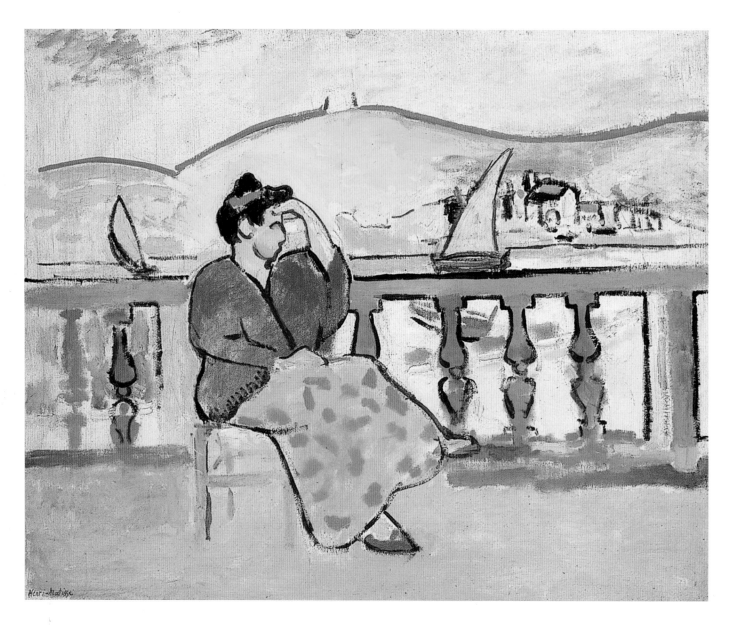

15. *Lady on the Terrace*,
 c. 1907.
 Oil on canvas,
 65 x 80.5 cm.
 The State Hermitage,
 Saint-Petersburg.

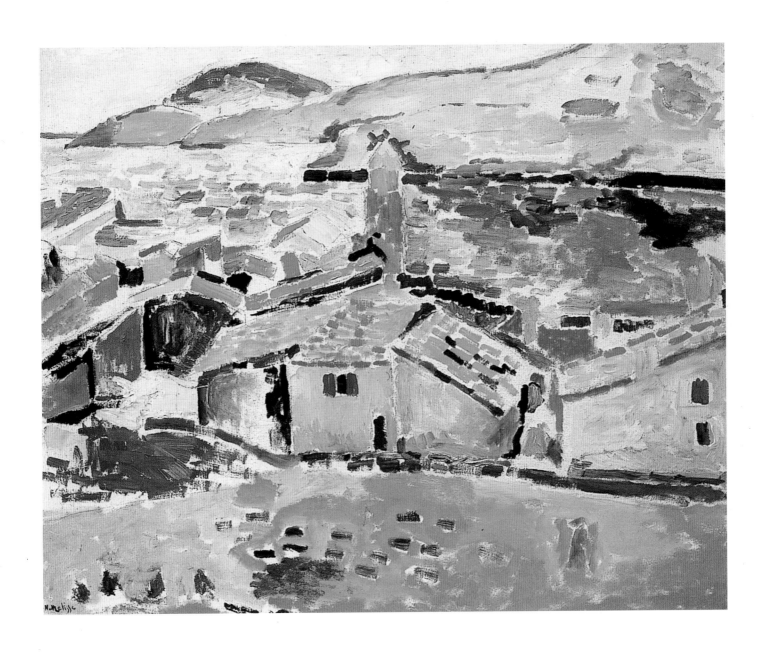

16. *View of Collioure*,
1906. Oil on canvas,
59.5 x 73 cm.
The State Hermitage,
Saint-Petersburg.

The years 1904-1905 found Matisse in Saint-Tropez and Collioure painting the Mediterranean coast. By now he was living and working in an artistic milieu and among the many artists and influential people he met were Paul Signac, Henry Edmond Cross, Aristide Maillol and Daniel de Montfreid, a friend of Gauguin's. In 1905 Signac bought Matisse's *Luxe, Calme et Volupté* (1904, Musée d'Orsay, Paris) and the following year Leo Stein acquired *Joie de vivre* (1905-1906, Barnes Foundation, Merion).

With Ambroise Vollard and the Americans Gertrude and Leo Stein buying his paintings, Matisse could now claim to have his own patrons. In 1908 the wealthy Russian collector Shchukin joined their number.

This period saw Matisse's material position steadily improve and as a result he was able to travel extensively — to Algeria, Italy, Germany and Spain. He also made etchings and worked in ceramics, as well as giving art lessons. In 1908 exhibitions of his work opened in New York, Moscow and Berlin.

In 1909 Shchukin commissioned him to paint the decorative panels The Dance and Music, which were brought to Russia at the end of the following year. In 1911 Matisse travelled there himself. The first decade of the twentieth century saw him and his friends come to the fore of the avant-garde in European and world art. In doing so they achieved the financial independence that was so important for their future work.

The Salon d'Automne scandal in 1905 brought Matisse fame and glory at a time when the preceding generation of artists were only just beginning to receive theirs. Matisse, as a natural inheritor of the French tradition, showed himself more than respectful of his elders. Renoir, whom he often met whilst in the south in 1917 and 1918, always remained a teacher figure for him.

The financial well-being Matisse now enjoyed freed him from many of life's restrictions. He continued to travel frequently and in 1927 his journeys even took him as far as Australasia. He often went to the USA, especially after 1930, when he received a commission from the Barnes Foundation to paint the decorative panel *The Dance* (1930, Barnes Foundation, Merion). In France Matisse divided his time between the Mediterranean coast and Paris, especially the studio at 19 Quai St.-Michel, where he had already worked as a young man.

Exhibitions of Matisse followed each other around Europe and America. The paintings, sculptures, ceramics and graphic works displayed attested to the amazing breadth of his creative abilities. As well as constantly painting, he simultaneously worked in theatrical design, most notably on Stravinsky's *Le Chant du rossignol* (1920) and Diaghilev's Ballets Russes in Monte Carlo in 1937. He also sculpted, illustrated books and produced lithographs. In the early 1930s, like many artists of his generation Matisse, working on a commission from Mine Coutoli, painted some wallpaper designs on cardboard. He returned to this field of design in 1946. During the Second World War Matisse illustrated a great number of books.

17. *A Game of Bowls*, 1908. Oil on canvas, 115 x 147 cm. The State Hermitage, Saint-Petersburg.

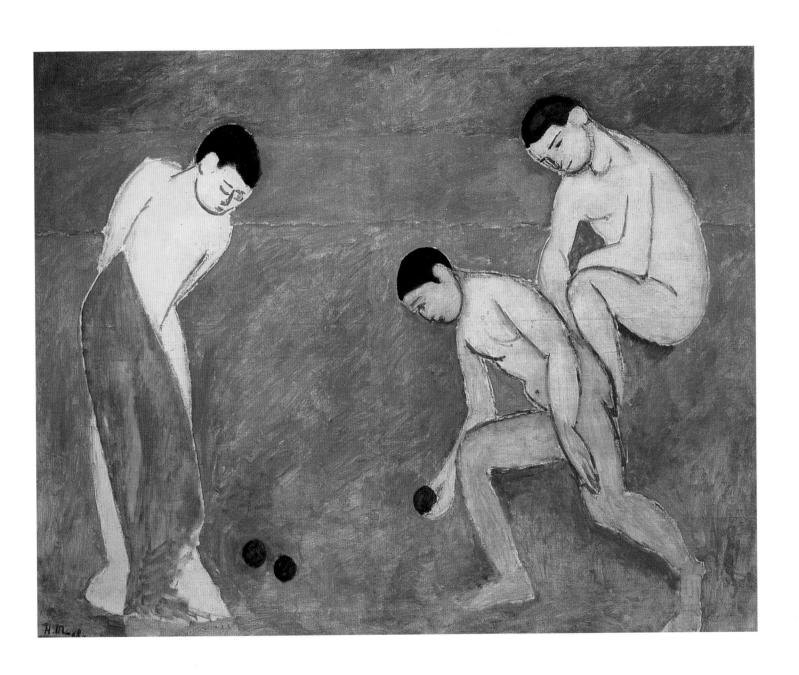

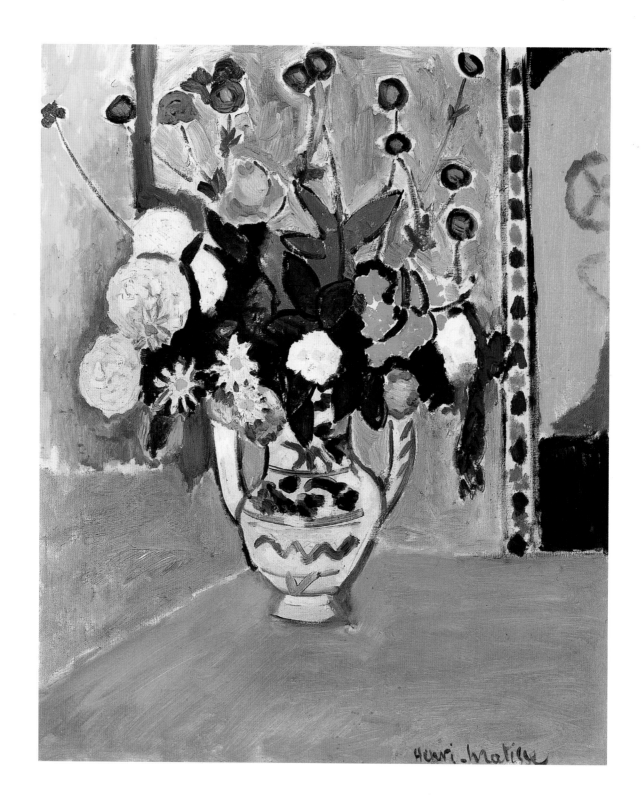

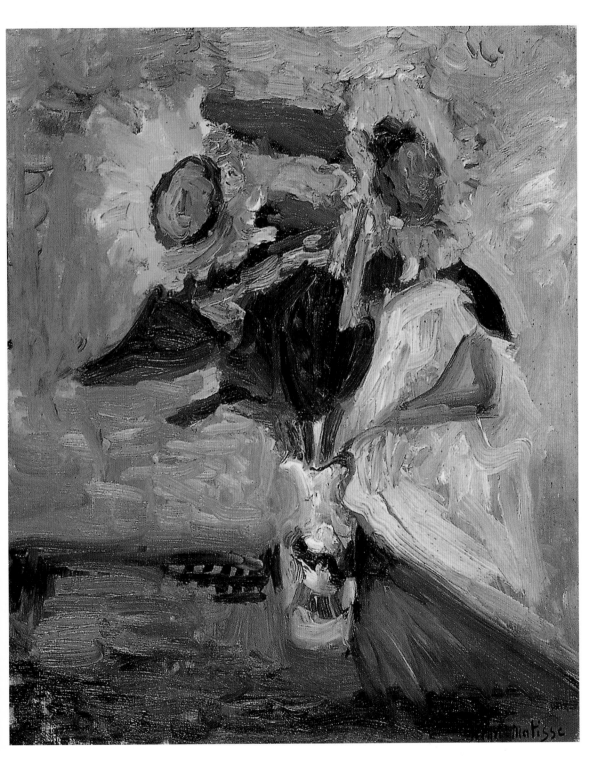

18. *Bouquet (Vase with two Handles)*, 1907. Oil on canvas, 74 x 61 cm. The State Hermitage, Saint-Petersburg.

19. *Vase of Sunflowers,* c. 1898. Oil on canvas, 46 x 38 cm. The State Hermitage, Saint-Petersburg.

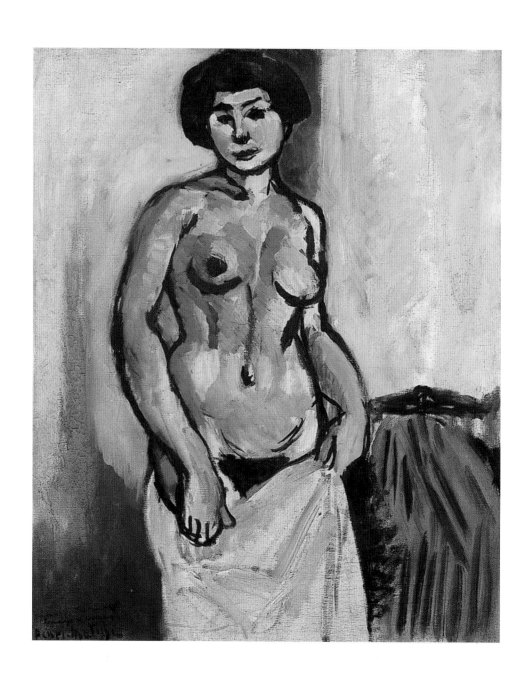

20. *Female Nude*, 1908.
 Oil on canvas,
 60.5 x 60 cm.
 The State Hermitage,
 Saint-Petersburg.

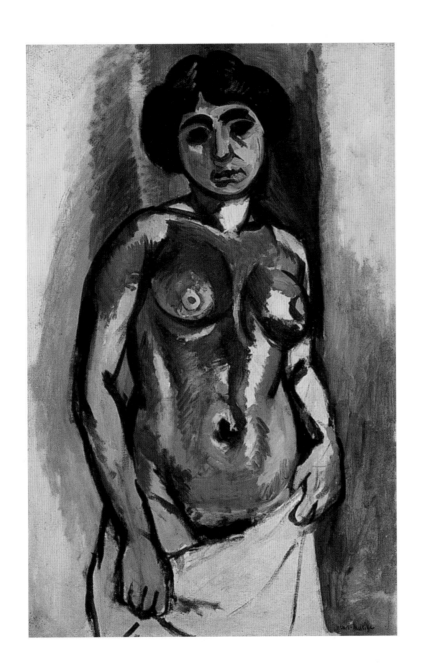

21. *Nude (Black and Gold)*, 1908.
Oil on canvas,
100 x 65 cm.
The State Hermitage,
Saint-Petersburg.

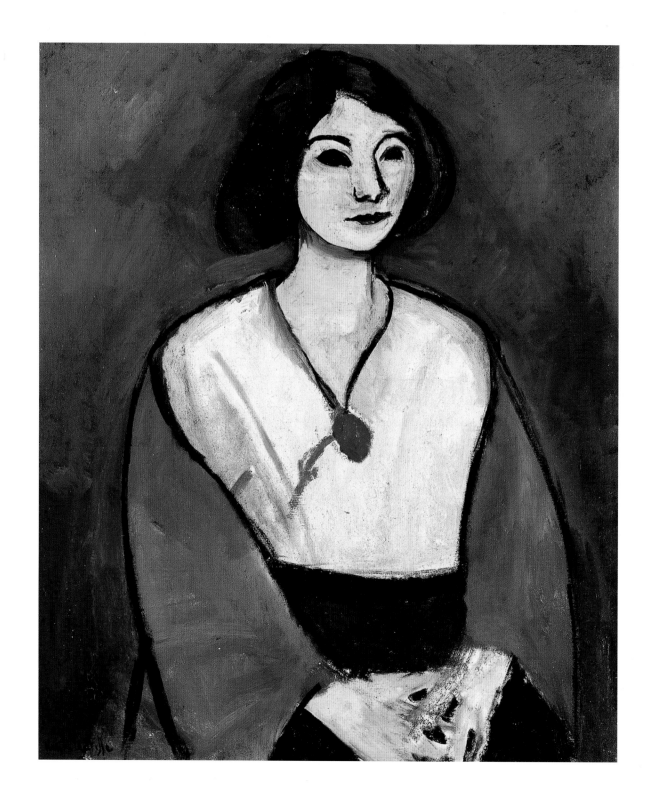

From 1941 onwards he produced a steady stream of illustrations included Henri de Montherlant's *Pasiphae* (1944), Charles d'Orléans' *Poems* (1950), Charles Baudelaire's *Les Fleurs du Mal* (I 946), Marianna Alcoforado's *Lettres de la religieuse portugaise* (1946) and *Jazz* (1947), and Pierre de Ronsard's *Le Florilège des Amours* (1948). Matisse continued to work even when confined to bed by illness. In 1947 he commenced a major work — the Rosary chapel in Vence — and the following year presented his first exhibition of "Engraved Gouaches".

These both brilliantly rounded off his lifelong experimentation in the realm of colour. Henri Matisse died in 1954 in Nice, already acclaimed as a great artist.

Matisse's work undoubtedly shows how in his nature rational intellect maintained constant hold over creative talent. Perhaps it is this facet that makes his work so difficult to interpret. The decisiveness he so evidently showed in his art means that he left no loopholes through which his individual emotional world can be reached (this is in complete contrast to other Fauvists like Vlaminck, Marquet, Van Dongen and Dufy). Matisse was convinced that "an artist's thinking should not be discussed without reference to the means he uses to depict it, because it is only of intrinsic value when it is borne out by these means ... which as a result become fuller ... just as the idea becomes more profound."

The paintings Matisse produced between 1897 and 1901 demonstrate the mastery of his predecessors' techniques, from the Impressionists through to Cézanne. Matisse began this process around the time of Gustave Moreau's death. Unlike Derain and Vlaminck he was never troubled by the "museum issue" since he learnt to appreciate exhibits and their influence under Moreau's guidance. Yet his methodical and independent approach remained with him even when he came across fresh artistic developments. Fascination with the colours used by the Impressionists on the flatness of an object in Cezanne's work (e.g. Fruit and Coffeepot, c. 1898, Hermitage), could impede his consistent movement towards the creation of his own paintwork space on the canvas. This is borne out by the following works which hang in the Hermitage: *Crockery on a Table* (1900), *Dishes and Fruit* (1901) and *The Luxembourg Gardens* (c. 1901) where the abstraction and the simplification of colour, which by 1908 became Matisse's own distinctive hallmark, become ever more apparent.

The search for Matisse's creative influences has acquired a special meaning. Matisse mastered one system after another — Impressionism, Cézanne and Neo-Impressionism — bringing each one into line with his own creative spirit, for example *View of Collioure* (c. 1905) and *Lady on the Terrace* (c. 1907), both in the Hermitage. These paintings together with *Vase of Sunflowers* (1898, also Hermitage) unexpectedly show the same density of texture for which Gauguin reproached Van Gogh, saying that the shape of the brush-stroke had lost contact with the shape of the object and that the form of the dab of paint had taken on a meaning of its own.

22. *Woman in Green with a Carnation*, 1909.
Oil on canvas,
65 x 54 cm.
The State Hermitage,
Saint-Petersburg.

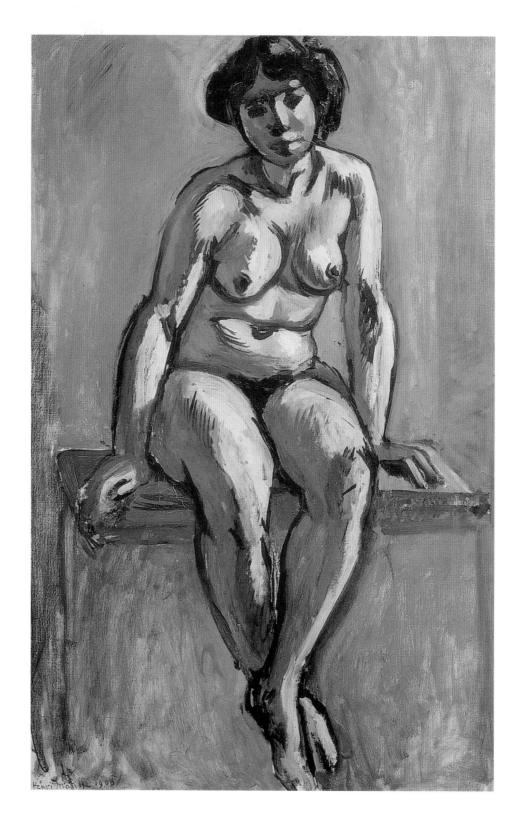

23. *Female Nude sitting*,
 1908. Oil on canvas,
 81 x 52.5 cm.
 The State Hermitage,
 Saint-Petersburg.

24. *The Gypsy,* 1906.
 Oil on canvas,
 55 x 46 cm.
 Musée de
 l'Annonciade,
 Saint-Tropez.

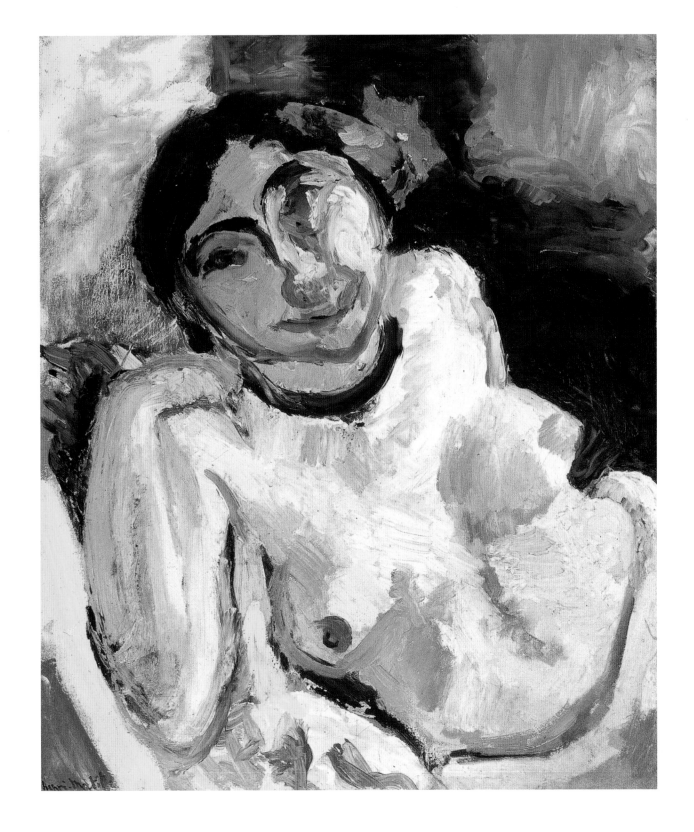

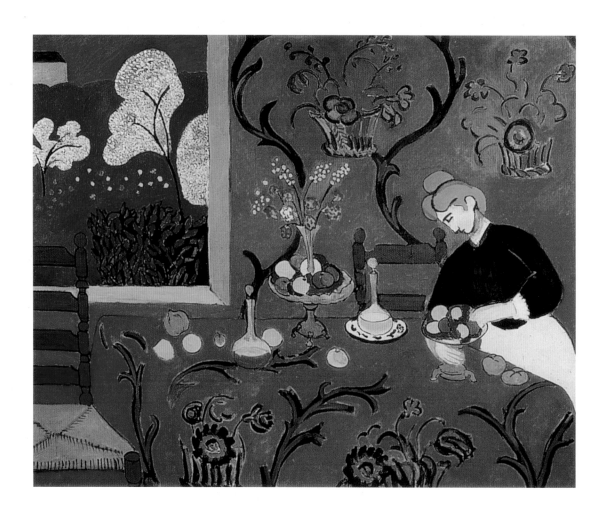

25. *The Red Room*
(Harmony in Red),
1908. Oil on canvas,
180 x 220 cm. The
State Hermitage,
Saint-Petersburg.

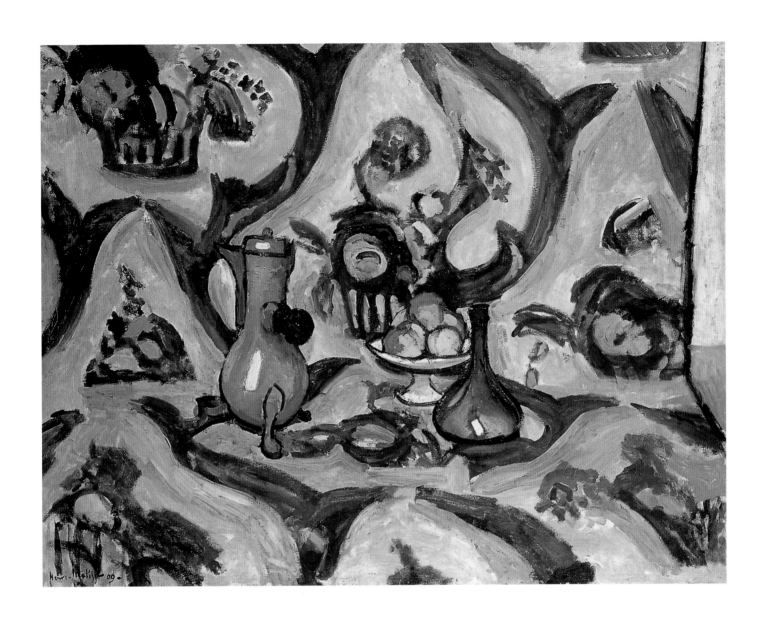

26. *Blue Table-cloth*,
1909. Oil on canvas,
88.5 x 116 cm. The
State Hermitage,
Saint-Petersburg.

If the assumed date of the *Vase of Sunflowers* is correct then the clear influence of Van Gogh's work in terms of both motif and style appeared in Matisse's work much earlier than the Van Gogh exhibition of 1901. Since it did not find a firm place in Matisse's developing artistic system it remained an isolated outburst. Yet the effect that Van Gogh's Sunflowers had on Matisse's work is evident in the three nudes from 1905 in the Hermitage collection — *Nude (Black and Gold)*, *Study* and *Seated Woman* — more in the choice of colour than in the emotional use of texture. The unexpected correlation of yellow ochre and greens concealed a great many possibilities. Matisse limited himself on the whole to yellow, green and black, yet even in these three works he showed different ways of conveying form and space, and, most importantly, showed the strength of a resonant colour without the use of additional shades. This can be seen as a consolidation of the principles of Fauvism without use of red. The still life *Vase, Bottle and Fruit*, now in the Hermitage, used to be dated to 1907. But the Hermitage curators now agree that this work was possibly painted in 1905-1906, because at that particular time Matisse made use of the motif of a light blue tablecloth in a dark blue painting. This, however, contradicts the assertion made by Matisse's daughter, Marguerite Dutilly, who says she first saw the still life in her father's studio in 1903. If this question is approached on the basis of artistic conception rather than material evidence then we find ourselves faced with a really extraordinary phenomenon. It is as if a whirlwind has suddenly swept past and completely shuffled the chronological order of Matisse's paintings. It upsets the thickness of the walls and the table; the form of object and cloth becomes uncertain; the blues, reds, yellows and greens tie themselves in a tight and beautiful knot in the centre of the canvas, and the texture changes from thick dabs of paint to fine almost watercolour-like layers.

According to Maurice de Vlaminck, Matisse first visited the studio where he and Derain worked in 1904 and left in raptures. "He returned the very next morning saying 'I couldn't close my eyes last night! I want to see it all over again...!' He quickly made us agree to exhibit our work at the Indépendants, which was due to open in April." Vlaminck and Derain first exhibited their work at the Salon des Indépendants in the spring of 1905. If the approximate dates given by Vlaminck and Matisse's daughter are to be believed, then the still life in the Hermitage was in fact painted a little earlier while Matisse was under the influence of Vlaminck's work, either at the end of 1904 or at the beginning of 1905.

Such extreme emotional responses were rare occurrences for Matisse, though. The logic of Matisse's artistic development can be quite clearly traced even within the limits of the Russian collections. The still life *Dishes and Fruit on a Red-and-Black Cloth* (1906, Hermitage) heralds the beginning of a period when Matisse experimented with using large areas of colour to construct a space, which was almost as flat as the canvas and yet did not lose the feeling of three dimensions.

27. *Spanish woman with a tambourine*, 1909.
Oil on canvas,
92 x 73 cm.
Pushkin Museum of
Fine Arts, Moscow.

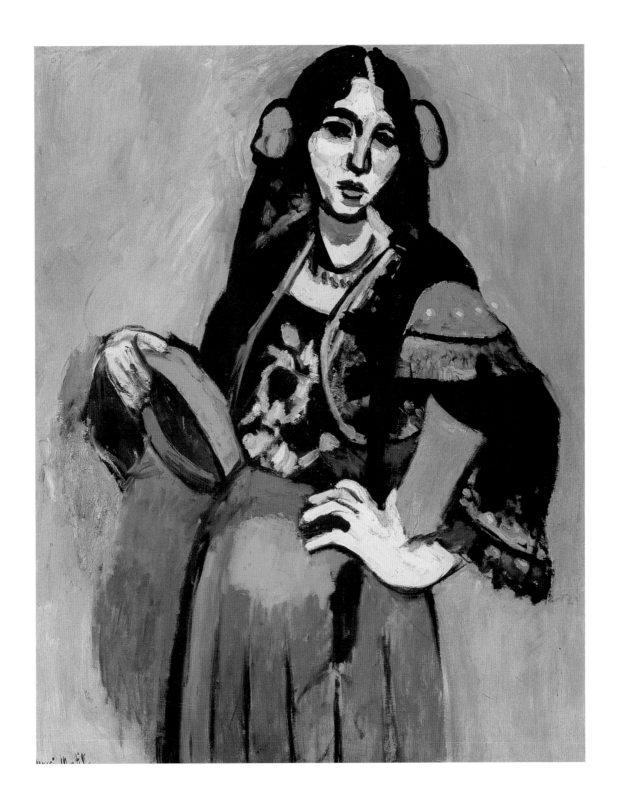

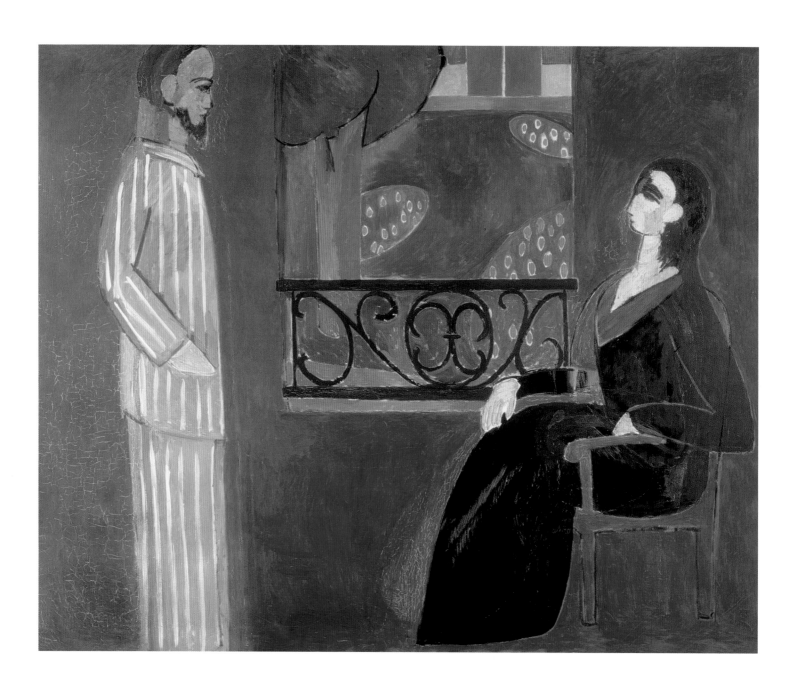

28. *The Conversation*,
c.1909. Oil on canvas,
177 x 217 cm.
The State Hermitage,
Saint-Petersburg.

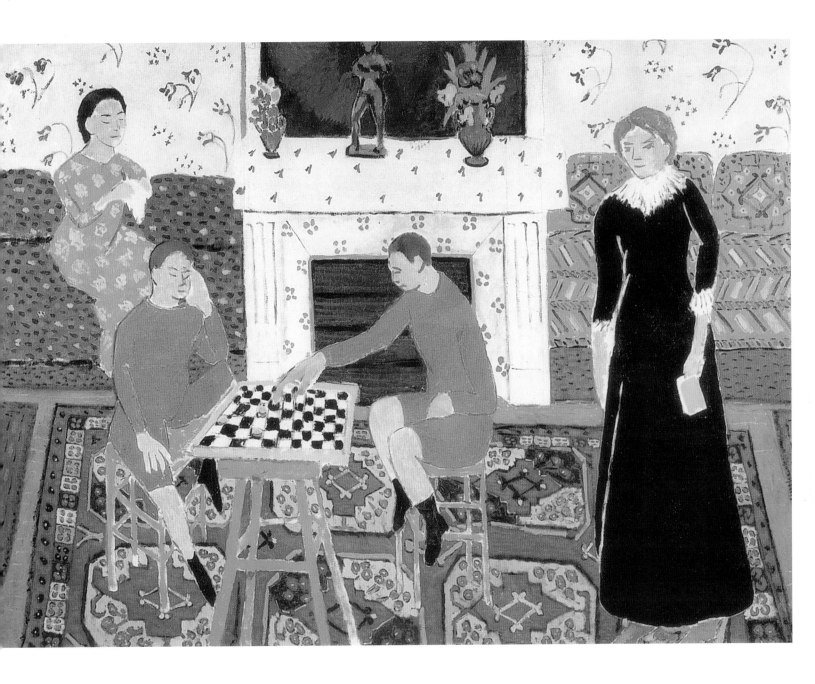

29. *The Painter's family*,
1911. Oil on canvas,
143 x 194 cm.
The State Hermitage,
Saint Petersburg.

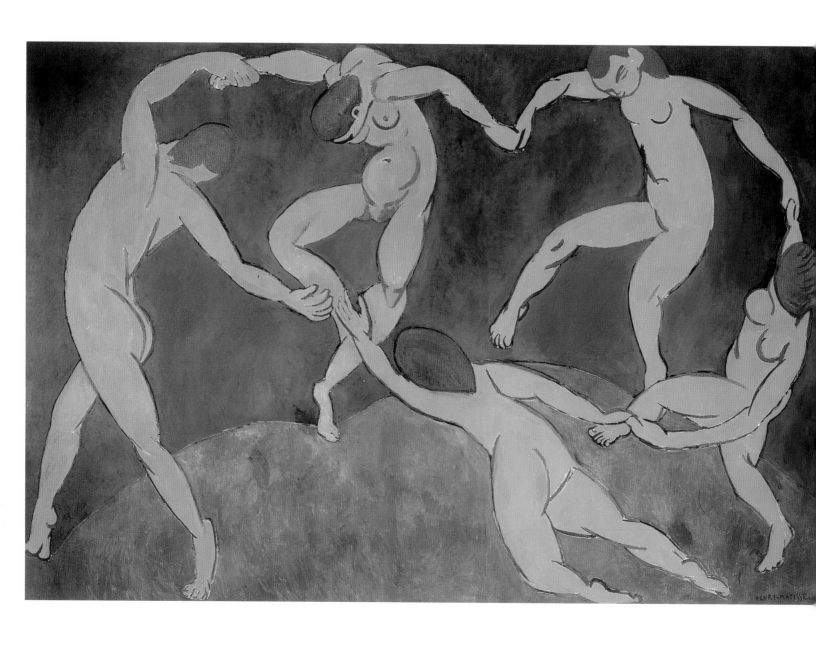

30. *The Dance*,
1909-1910. Oil on
canvas, 260 x 391 cm.
The State Hermitage,
Saint-Petersburg.

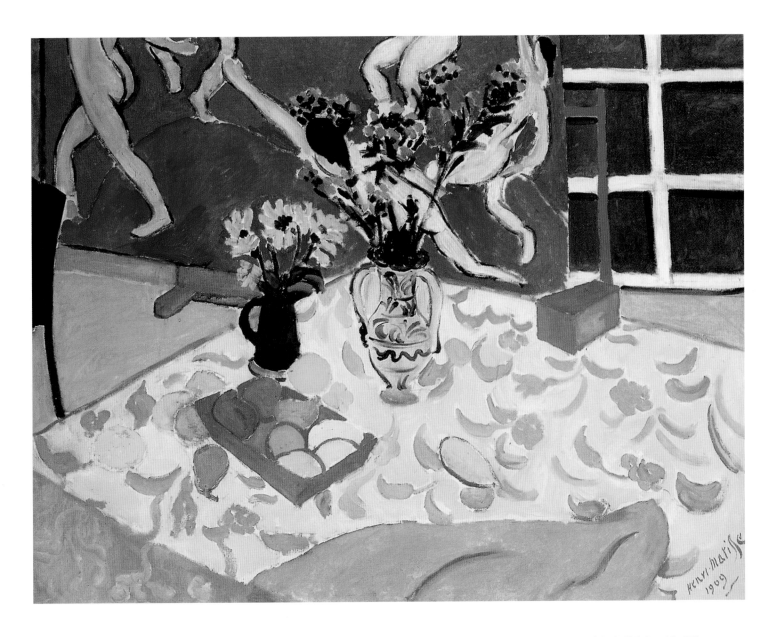

31. *Still life with "The
Dance",* 1909.
Oil on canvas,
89.5 x 117.5 cm.
The State Hermitage,
Saint-Petersburg.

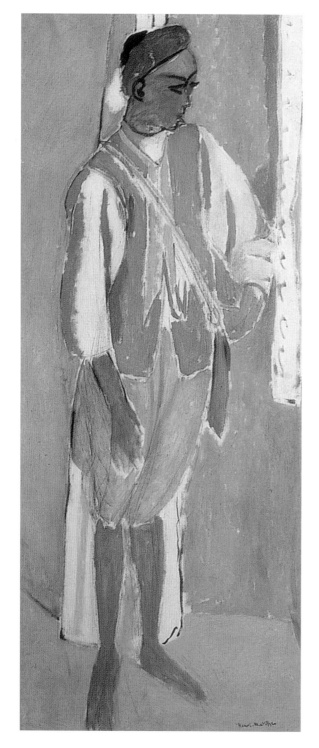

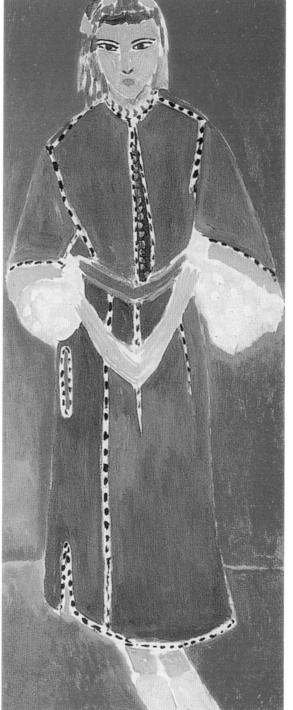

In *Statuette and Vases on an Oriental Carpet* (1908, Pushkin Museum of Fine Arts) the carpet hanging on the wall and covering the table gave Matisse the opportunity to split the space he had created. In this painting the standing objects are the only means used to denote the transition from the horizontal surface to the vertical.

However, in *Fruit and a Bronze* (1910, Pushkin Museum of Fine Arts) these objects — the jugs, vases, statue and fruits — become more and more a part of the general ornamental structure, so that this relative boundary dividing the surface is gradually smoothed over, as it were.

This searching process produced the painting *The Red Room* (1908, Hermitage) which optimally attained the target Matisse had set himself. "I want a balanced art which is pure and tranquil. I want a man who's tired, over-worked and on his last legs to find peace and repose in my work."' In 1908 he began a large painting of an interior which featured a still life and a landscape seen through a window. By his own accounts Matisse was so disillusioned by the poor correlation of the green beyond the window and the green of the interior that he reworked the painting (which was to have been called Harmony in Green).

It reappeared that same year at the Salon des Indépendants entitled *Harmony in Blue* and some idea of what Matisse was striving for can be gleaned from a similar painting in the Hermitage — *Still Life with a Blue Tablecloth* (1909). Matisse's striving to divide areas in a way which worked led him to resolve completely the issue of decoration in *Harmony in Blue*. The painting now acquired a light blue cloth while the thick separations which had been there in Harmony in Green, were retained because they helped create a flat form that is a particular feature of this work. This feeling is not disturbed but enhanced by the warm colours found in the pitcher and the fruits.

The reasons why Matisse did not like *Harmony in Blue* deserve some thought. He asked Shchukin for a postponement of delivery and subsequently in 1909 gave the collection *The Red Room* instead. We can suppose that the beauty of the small-scale *Still Life with a Blue Tablecloth* became rather monotonous in the huge dimensions of *Harmony in Blue*. The repainted work with the dark blue design on a deep red background at last acquired the feeling of peace and monumentality which the artist had searched for.

Nothing in the painting disrupts the unity of the patterned surface; the lines of the table and chair, receding in keeping with perspective, give no more than a hint of the depth of the space in the painting. The way that the dimensions correspond with each other is another important feature: the divisions of the cloth are too large and the fruit is, in comparison, too small, but their colours accord perfectly, and they remind the viewer of the colourful harmony found in old French Mille Fleurs tapestry.

32. *The Moroccan Amido*, 1912. Oil on canvas, 146.5 x 61.3 cm. The State Hermitage, Saint-Petersburg.

33. *Moroccan Woman (Zorah standing)*, 1912. Oil on canvas, 146.5 x 61.7 cm. The State Hermitage, Saint-Petersburg.

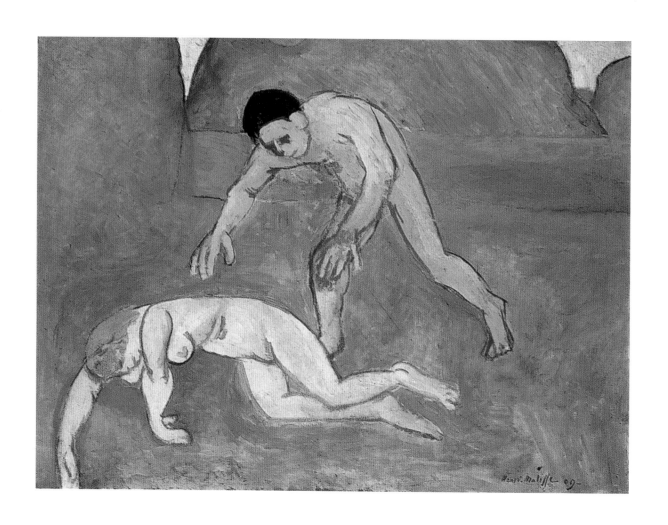

34. *Satyr and Nymph*,
 1909. Oil on canvas,
 89 x 116.5 cm.
 The State Hermitage,
 Saint-Petersburg.

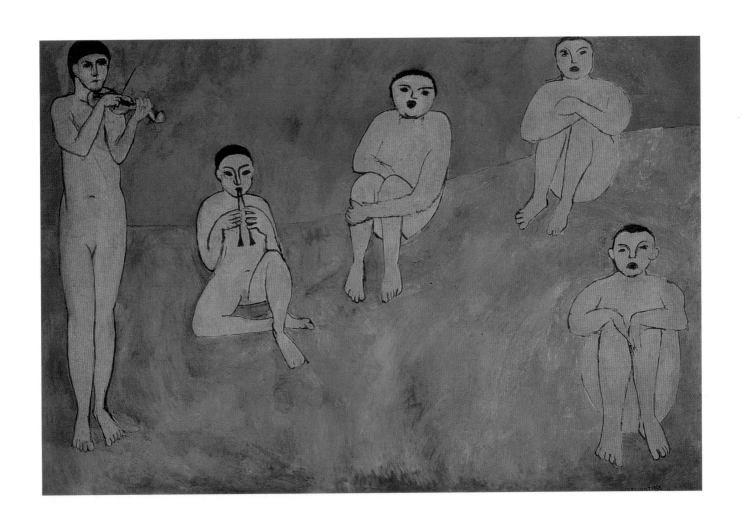

35. *The Music*, 1910.
Oil on canvas,
260 x 389 cm.
The State Hermitage,
Saint-Petersburg.

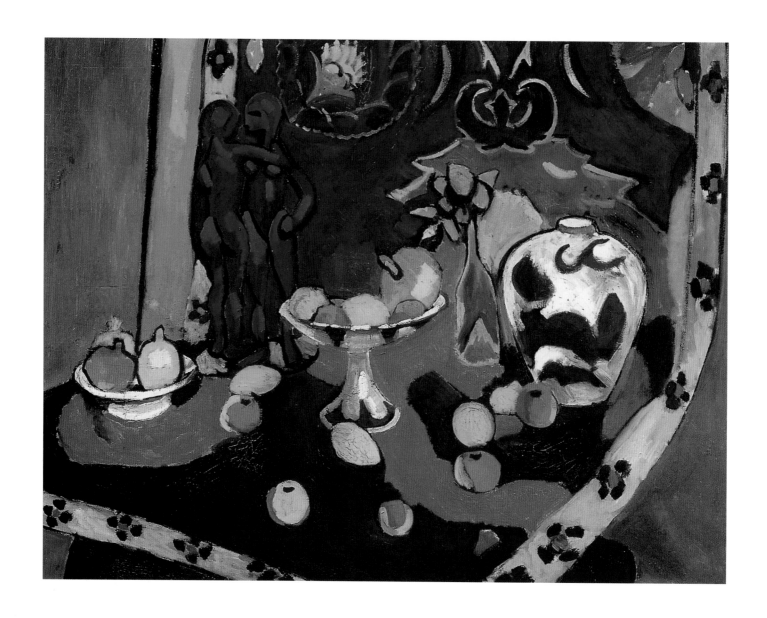

36. *Bronze and Fruits*,
1910. Oil on canvas,
90 x 118 cm. Pushkin
Museum of Arts,
Moscow.

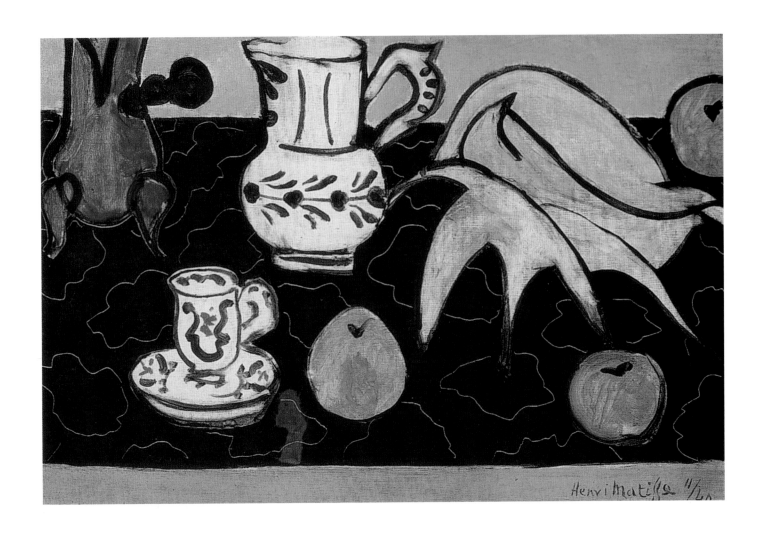

37. *Still Life with mussel on black marble*, 1940. Oil on canvas, 54 x 81 cm. Pushkin Museum of Fine Arts, Moscow.

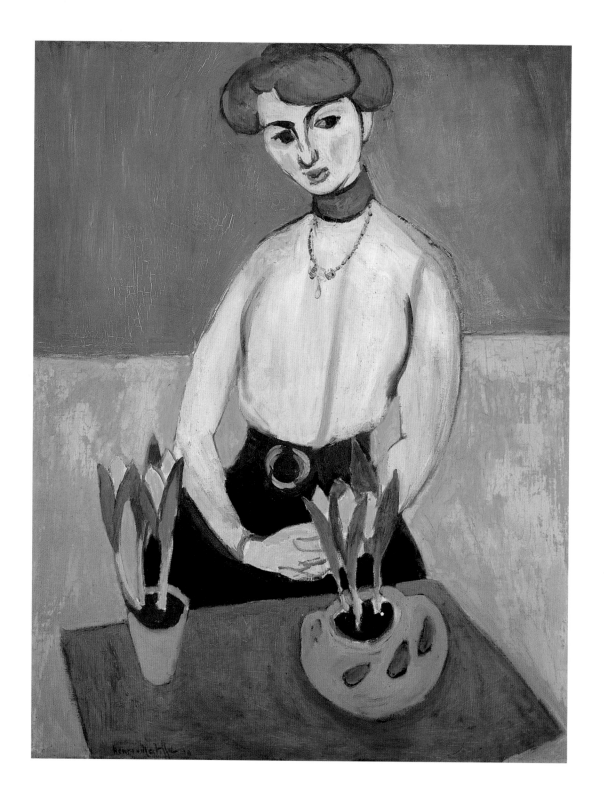

38. *Girl with tulips
(Portrait of Jeanne
Vaderin)*, 1910.
Oil on canvas,
92 x 73.5 cm.
The State Hermitage,
Saint-Petersburg.

The intense joy which the work of the Primitives in the Louvre had imbued in Matisse was never lost, and the staging in 1904 in the Grand Palais of a major retrospective of the French Primitives featuring paintings, Limoges enamels and carpets, rekindled this sensation.

Whenever Matisse reworked his impressions the result was never an adoption but rather an interpretation and organization of the original material. In this particular case the task at hand lay in subduing a large area of red. To achieve this Matisse used decorative techniques which he adopted from the French carpet weavers. An avalanche of colour remains weak, he said. "The full potential of colour is only realized when it is organized, when it reflects the artist's emotional intensity." Matisse continued the process of subduing a large area of colour in *Conversation* (c. 1909, Hermitage). This painting goes the way of further simplification. Matisse discarded the pattern which adorns *The Red Room*, and now employed two areas of colour to disrupt the dark blue surface, one light blue with a white stripe and the other black. Red appears only as a fine sprinkling on the landscape seen through the window, considerably less in scale than the use of dark blue on red in the preceding composition.

Following Matisse's work chronologically one can see that each new painting is in its own way a result of his previous searches, as well as being a basis for further development. *Harmony in Blue* was described in the Salon d'Automne as "a decorative panel for a dining room (owner Mikhail Shchukin)." Matisse's own artistic method — the large colour surfaces correlating with pattern — lead one to think of this painting in coexistence with architecture. "The canvas introduces a new element to the room which it enters," said the artist. Shchukin's commissioning of a decorative panel for his Moscow home was an appropriate conclusion to the course Matisse had been following until then. The chain of thought which brought Matisse to *The Dance and Music* can be traced within the two major Russian collections. In the 1908 painting A *Game of Bowles*, now in the Hermitage, Matisse tried to resolve two issues: first, decorative abstraction with a strong concentration of colour — dark blue, green and ochre yellow; second, the creation on the surface of the canvas of a balanced form based upon the classical triangle. The direction taken in colour was continued in *Nymph and Satyr* (1909, Hermitage). However this painting also saw the introduction into the classical pyramid of crisp and vigorous arched lines capable of giving a painting balance in combination with the motion of the figures which it contains. Three paintings in Russian museums feature a depiction of a large sketch for The Dance in an Interior — a frequent motif for Matisse. They are *Fruit, Flowers and "The Dance"* (1909, Hermitage), *Nasturtiums and "The Dance"* (1912) and *A Corner of the Artist's Studio* (1912, both in the Pushkin Museum of Fine Arts).

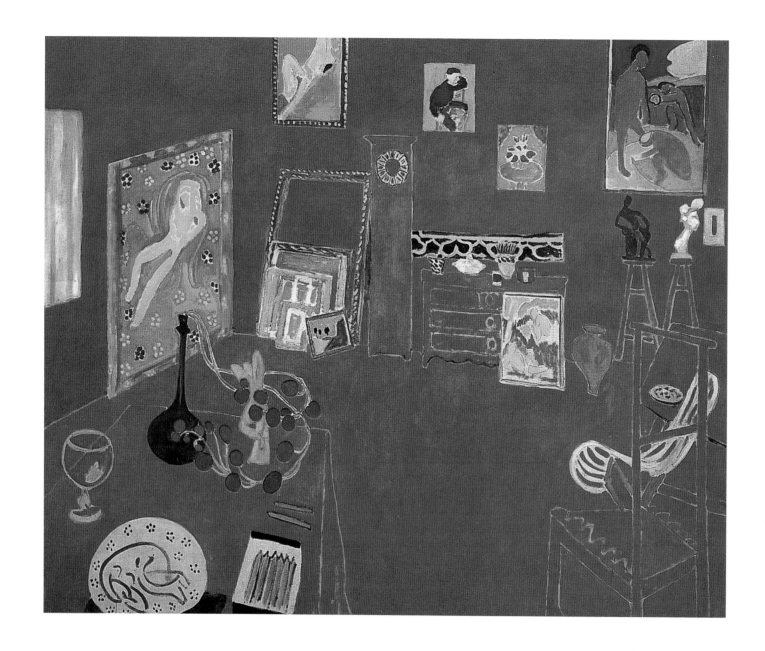

39. *The Red Studio,* 1911.
Oil on canvas,
191 x 219.1 cm.
Museum of Modern
Art, New York.

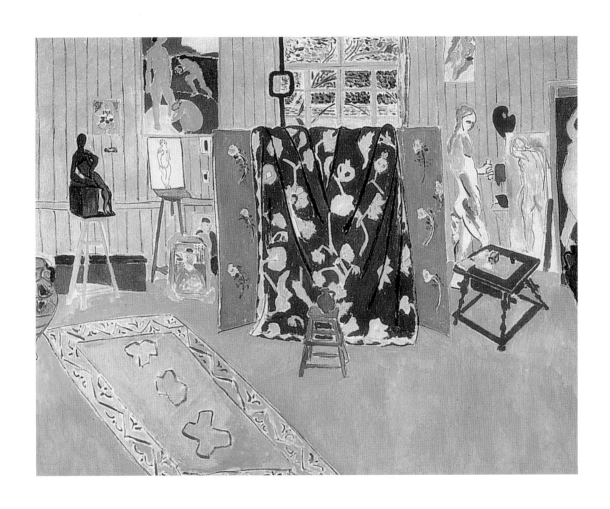

40. *The Artist's studio*,
 1911. Oil on canvas,
 180 x 221 cm.
 Pushkin Museum of
 Fine Arts, Moscow.

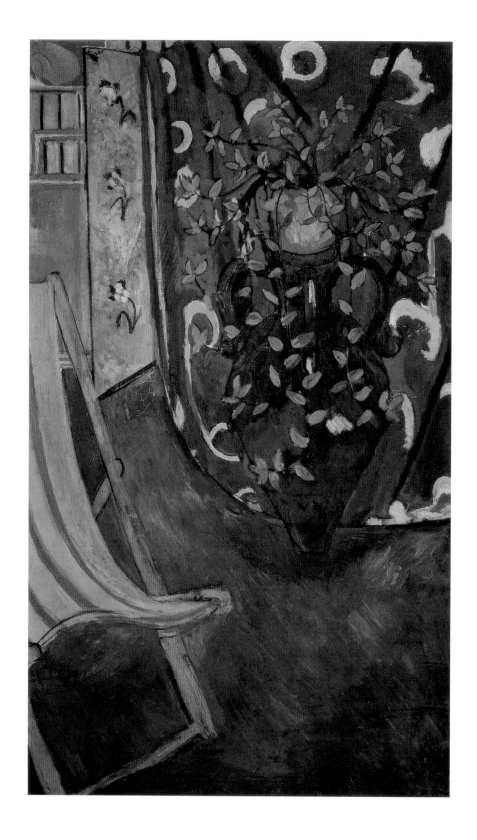

41. *Studio Corner*, 1912.
Oil on canvas,
193 x 115 cm.
Pushkin Museum of
Fine Arts, Moscow.

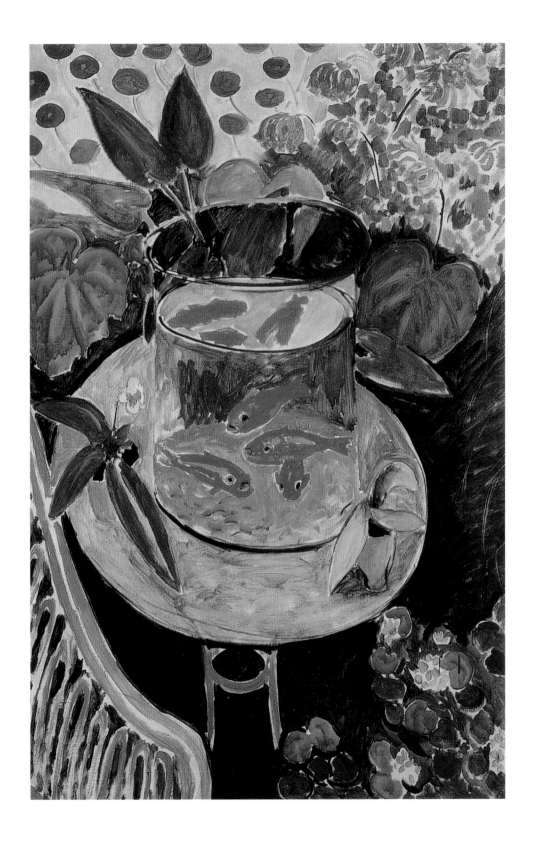

42. *Red Fish,* 1912.
Oil on canvas,
140 x 98 cm.
Pushkin Museum of
Fine Arts, Moscow.

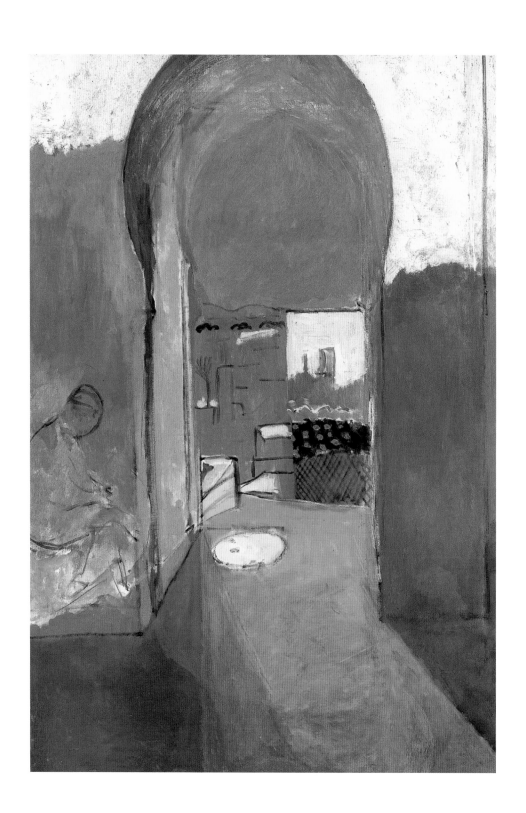

43. *The Casbah Gate,*
1912. Oil on canvas,
116.5 x 80 cm.
Pushkin Museum of
Fine Arts, Moscow.

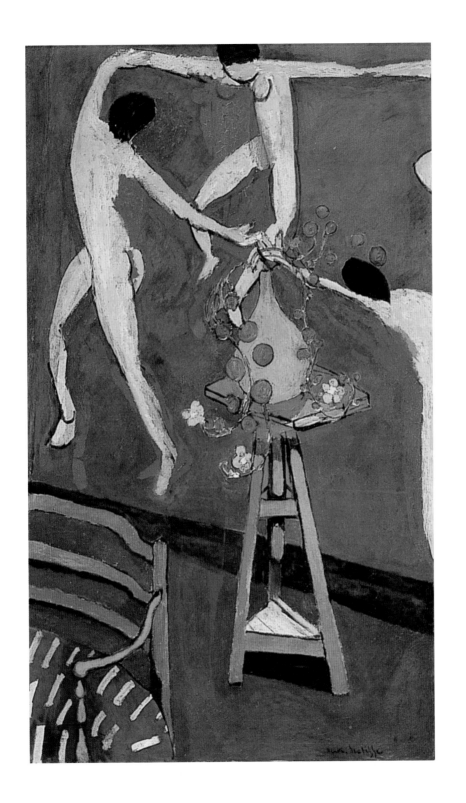

44. *"The Dance" with Nasturtiums*, 1912. Oil on canvas, 193 x 114 cm. Pushkin Museum of Fine Arts, Moscow.

In these works Matisse appears to have completely resolved how to depict the round dance in principle. This subsequently was reduced to the extreme concision typical of Matisse in all aspects of the work. For Matisse to have reached this stage, researchers are convinced, probably with justification, that he must have spent some time observing real-life dancers. It must be noted that the idea of the round dance — balance and movement — can be traced quite far back in Matisse's own work, to *A Game of Bowles* (1908) and to the design on the ceramic vase he made in 1907. The idea could have arisen indirectly from the very outset, prompted perhaps by an ancient ceramic work of the French Primitives, if not the Limoges enamels, or some source still harder to determine.

In *The Dance* as we see it in the Hermitage, Matisse brought the motif to such a degree of perfection that it made all further attempts at development not only superfluous, but impossible. This view is confirmed by the later variants, notably by the wall painting for the Barnes Foundation in Merion. The paintings *Music* and *The Dance* are inseparable parts of a single decorative concept. The intense wild rhythm of *The Dance*, which confronted visitors to Shchukin's house on the first-floor landing, was supplanted by the conciliating peace of the second panel which hung on the next landing.

In *Music* the level of the horizon is higher and the relative weight of the green surface has been increased. The construction is reduced to a primitive pattern — the canvas is cut by a diagonal line of orange figures framed by two vertical lines. In reducing composition to a bare minimum, Matisse made changes directly on the canvas without the use of many preliminary sketches. What is remarkable in these paintings is that the alterations of one single element — the proportional relationship in the configuration of areas of colour results in dynamic motion in The Dance and a diametrically opposed stasis in Music.

The variety of works by Matisse in the Russian museums nonetheless reflects the unity of his searches on canvas, and the consistency and methodical nature of his artistic thinking. The varying correlations between dark blue, green and yellow-red in Matisse's decorative works developed in subtle nuances in his portraits. The way in which the model's individuality develops from *Lady in Green* (c. 1909, Hermitage) with its mixture of Renaissance precision and contemporary concision of line, through *Girl with Tulips* (*Portrait of Jeanne Vaderin*, 1910), to *Portrait of Madame Henri Matisse* (1913) — all in the Hermitage, follows essentially the same route — reducing the visual idiom concision.

Although the two portraits of Lydia Delektorskaya (*Young Woman in a Blue Blouse*, 1939, and *Portrait of Lydia Delektorskaya*, 1947, both in the Hermitage) were painted several decades later and with a long interval between them they both essentially show Matisse continuing the search for an exactness of line and proportions between different areas while still working with the same colours — green, dark blue and reddish-yellow.

45. *Zorah on the terrace,* 1912. Oil on canvas, 116 x 100 cm. Pushkin Museum of Fine Arts, Moscow.

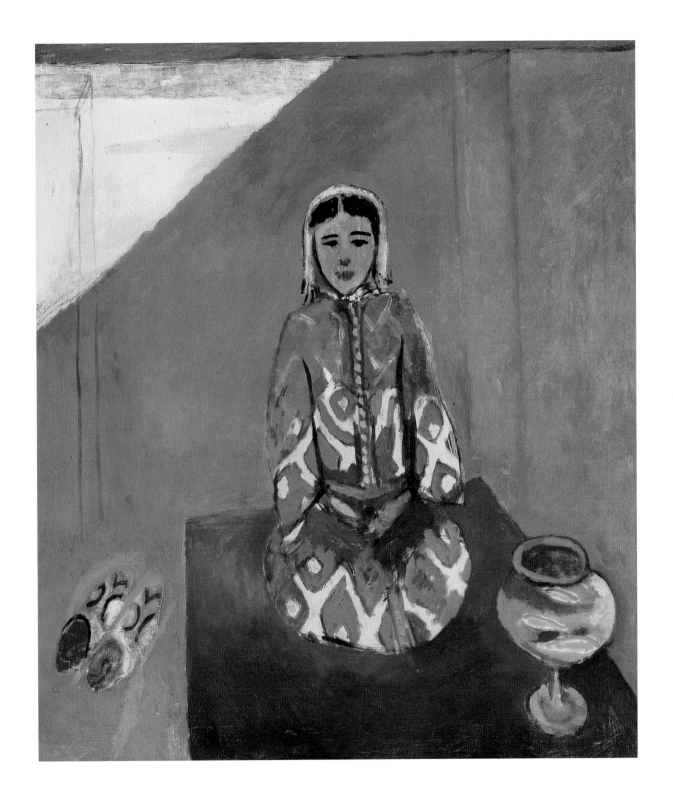

46. *Portrait of Madame
 Henri Matisse,* 1913.
 Oil on canvas,
 146 x 97.7 cm.
 The State Hermitage,
 Saint-Petersburg.

47. *Self Portrait,* 1918.
 Oil on canvas,
 63.5 x 53.3 cm.
 Private collection.

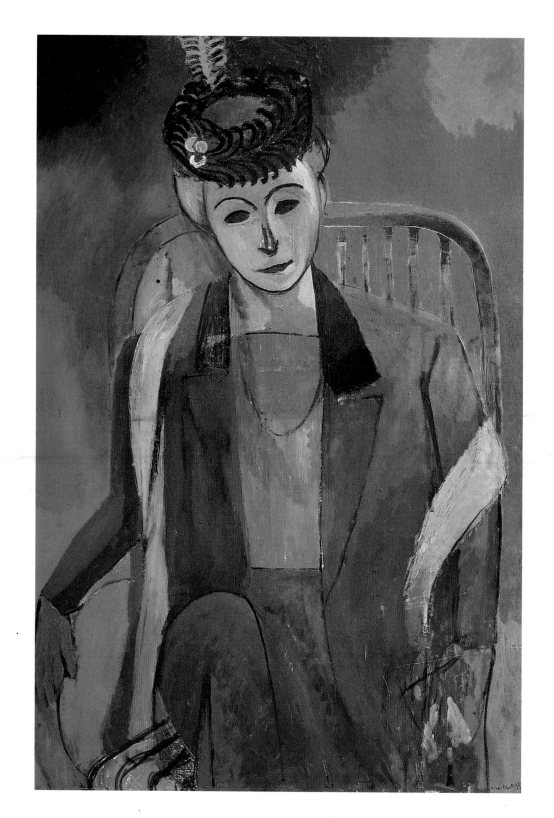

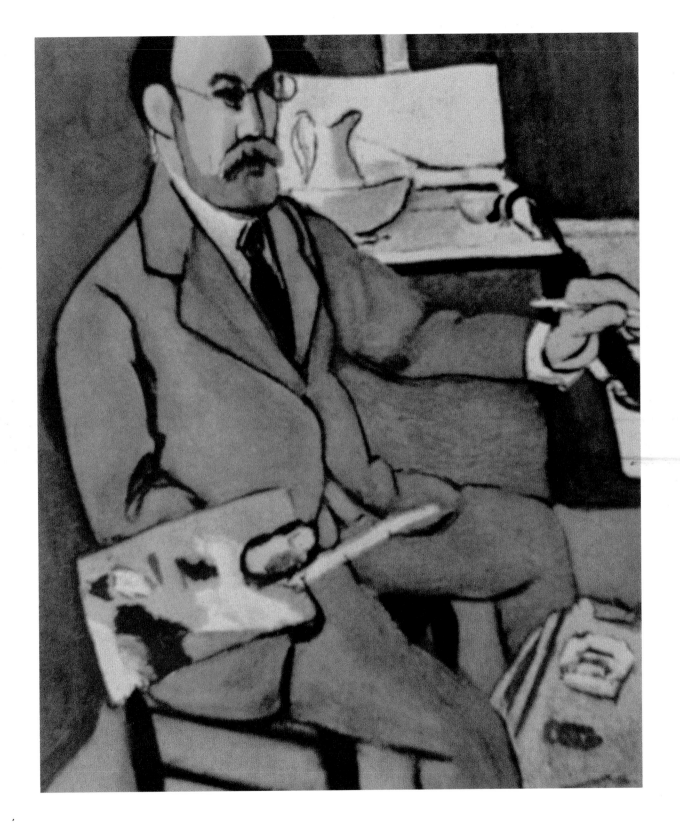

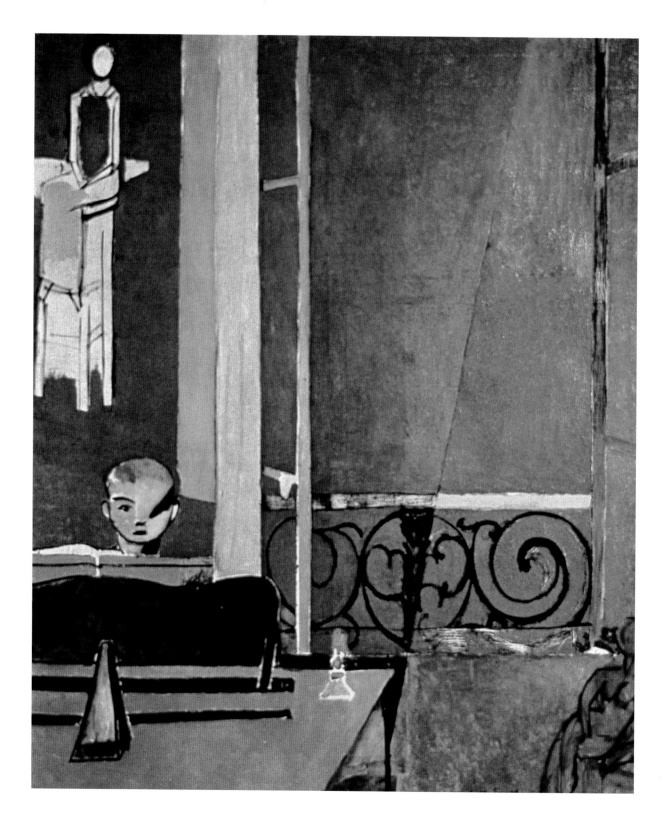

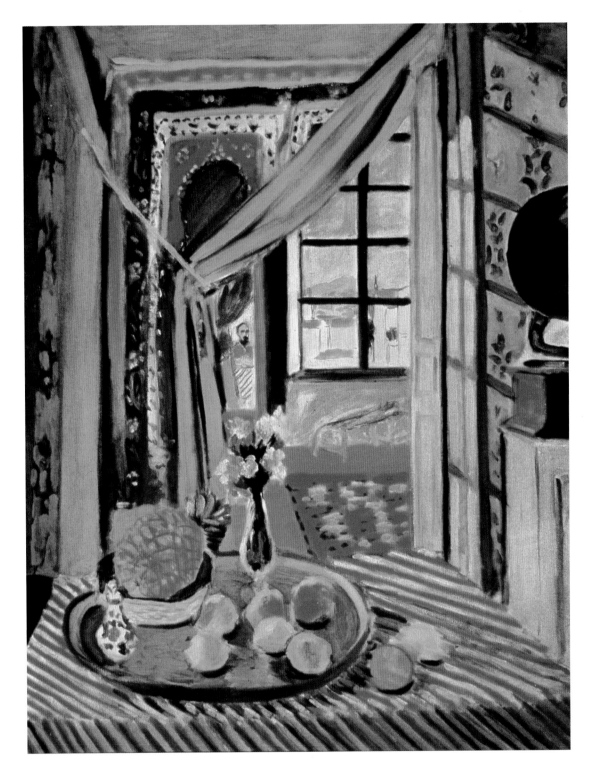

48. *Piano Lesson*, 1916.
Oil on canvas,
245.1 x 212.7 cm.
Museum of Modern
Art, New York.

49. *Interior at Nice*, 1924.
Oil on canvas,
99 x 81.2 cm.
Barnes Foundation,
Merion, Pennsylvania.

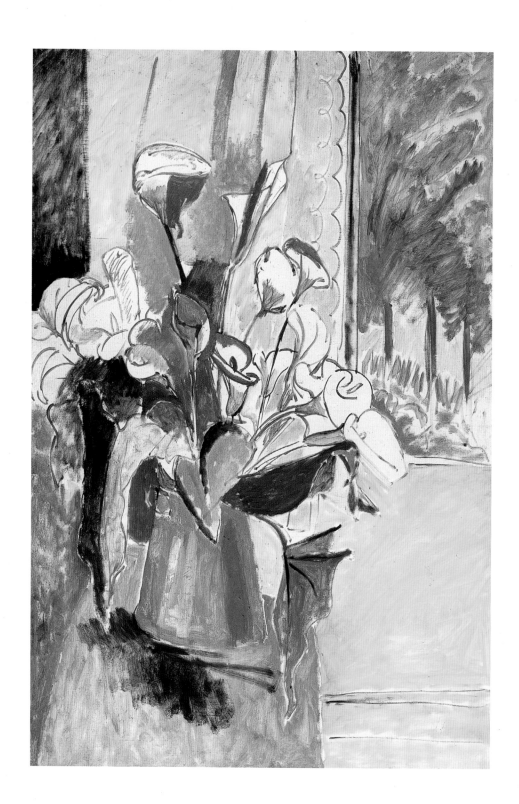

50. *Bouquet of Flowers
on the veranda*, 1913.
Oil on canvas,
146 x 97 cm.
The State Hermitage,
Saint-Petersburg.

Particular attention should be paid to the influence Eastern art exerted on Matisse. This was never a factor with any of the other Fauvists — Japanese art had been assimilated by preceding generations, while the previously unknown works of Muslim art aroused no more than an impression of the exotic like the African statuettes which Vlaminck discovered. But there was Pablo Picasso, the only person in whom African art found a direct outlet and there was Henri Matisse who similarly went against the grain by finding inspiration in the Muslim art exhibitions held in Paris in 1903 and in Munich in 1910. The first of these, together with Matisse's journeys to North Africa, prompted the introduction of concrete Eastern objects in his work — the decorative qualities of which furthered the compaction and simplification of space in his still lifes — rather than thoughts of any sort of new possibilities in painting.

Matisse was not an impulsive man by nature, and a certain length of time was required for an idea to come to fruition in his art.

The new impressions he gained at the Munich exhibition in 1910, and also from his journeys to Spain in 1910-1911, and to North Africa in 1910-1913 (in the company of Albert Marquet and Charles Camoin) laid the foundation for the development of the arabesque in his work. The arabesque is a completely logical motif for Matisse to have used in his search for a new means of depicting space on a flat surface. The Eastern pattern with its delicate beauty coupled with a free, simple pattern and colouring, fed Matisse's imagination at this stage in his artistic development. Two paintings in the Hermitage from the years 1910-1911, *Seville Still Life* and *Spanish Still Life*, feature one and the same set of objects which lose their individual significance and become simply an opportunity for the artist to create different patterns almost as if he were playing with kaleidoscope.

Now Matisse was using not Eastern objects, but any kind of fabric, fish in an aquarium, even a pot of geraniums. Matisse saw arabesques in his own studio, in its sculptures, easels, and canvases (*A Corner of the Artist's Studio*, 1912, Pushkin Museum of Fine Arts). Charles Chassé believes that it was Moreau who passed on this interest in the East to Matisse.

But the symbolic subjects and Eastern riches that are to be found in the teacher's paintings are as far removed from his pupil's work as the civilizations of the ancient East are from that of twentieth-century Europe. Fish became the centre of an ornamental design constructed using the concentric circles of the bowl and the table. The Fauvist red enters a tender and delicate environment where splashes of green are sprinkled on pink and pink on green (*Goldfish*, 1911, Pushkin Museum of Fine Arts). The influence of the East finally separated Matisse's decorative art not only from the Impressionists' objective observation of nature but also from the intimate world of the Nabis, thus introducing one further element in the character of Fauvism.

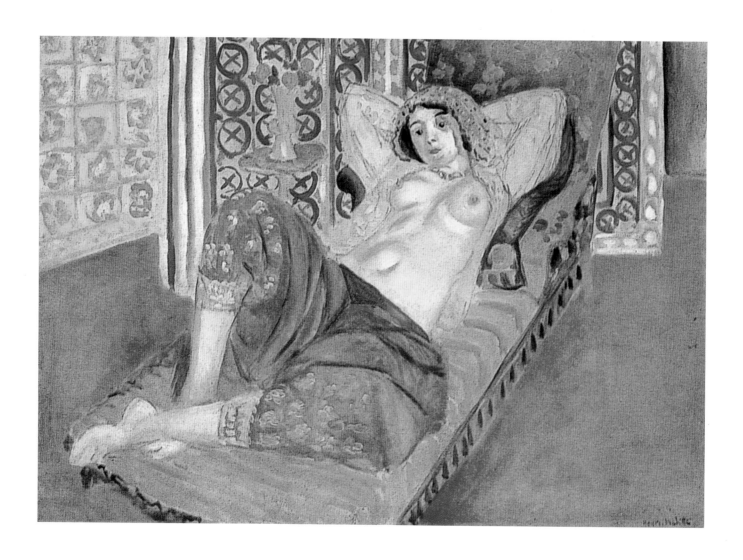

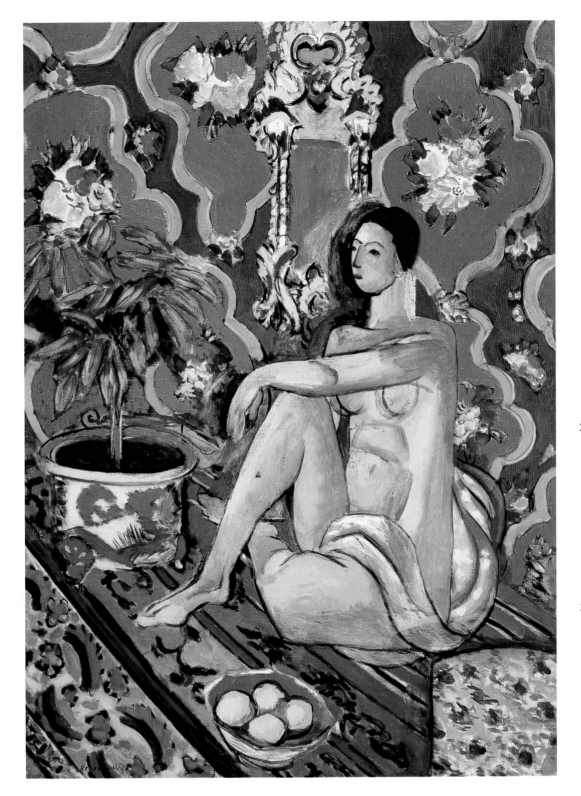

51. *Odalisque with Red Trousers*, 1921.
Oil on canvas,
65 x 90 cm.
National Museum of Modern Art, Georges Pompidou Centre, Paris.

52. *Decorative Figure on an Ornamental Background*, 1925.
Oil on canvas,
131 x 98 cm.
National Museum of Modern Art, Georges Pompidou Centre, Paris.

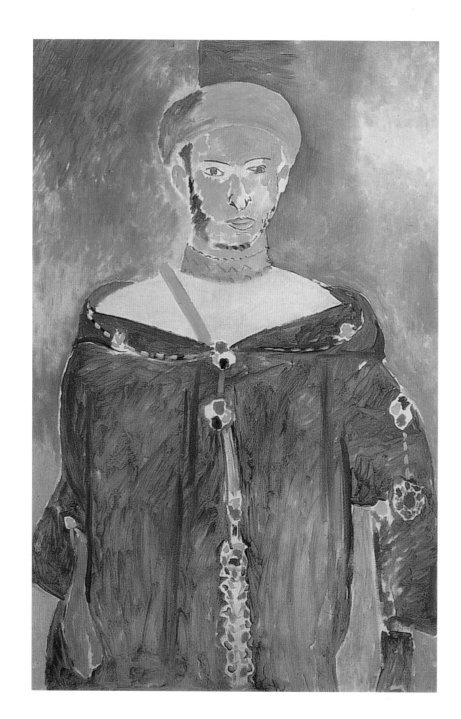

53. *The Moroccan in green*, 1913. Oil on canvas, 146.5 x 97.7 cm. The State Hermitage, Saint-Petersburg.

54. *Arab coffee house*, 1913. Egg tempera on canvas, 176 x 210 cm. The State Hermitage, Saint-Petersburg.

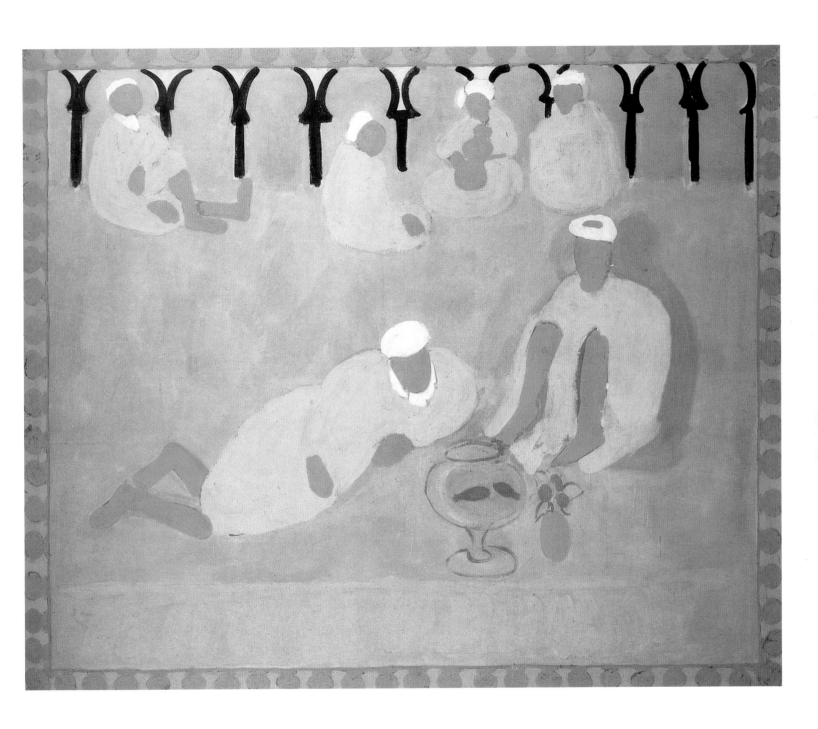

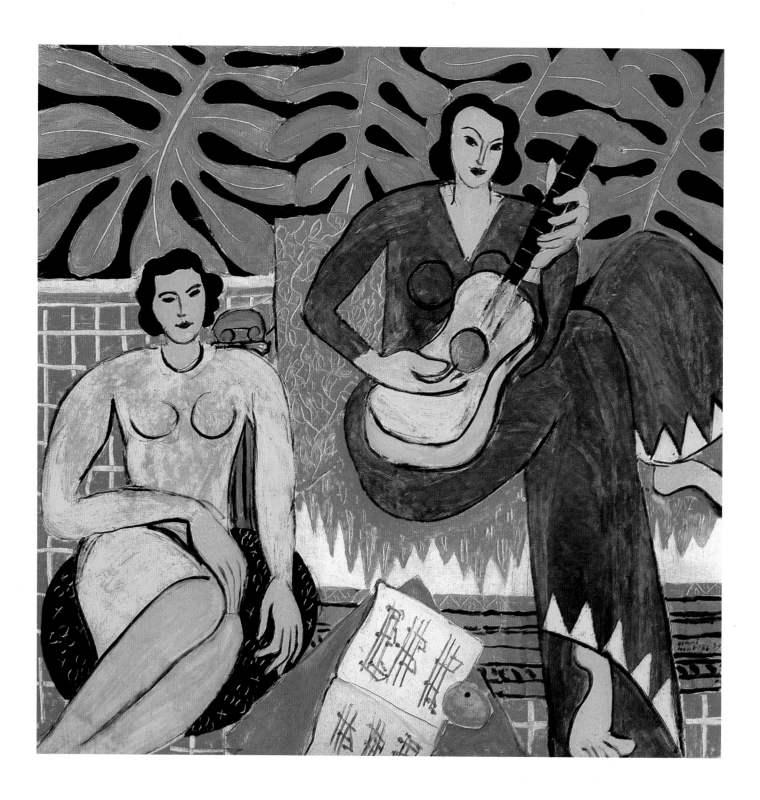

The Painter's Family (1911, Hermitage) is a concentrated expression of the principles of twentieth-century European art, including Fauvism with its distinctive re-working of external influences. The painting's motif derives directly from the work of the Nabis and even the execution in no way contradicts Edouard Vuillard's principles, for the work clearly depicts man in his surroundings rather than being just a mere portrait.

In painting the room — the carpet, couches, wallpaper, draughtboard and objects on the mantelpiece —Matisse worked with the accuracy and spontaneity of a Primitive artist. At the same time he constructed an absolutely pure classical composition: the red patch of the boy's clothing against a dark ground along the vertical axis is reinforced by the statuette on the mantel-piece; the centre of the work is framed by the rectangular fireplace and the two figures on its left and right sides. The sense of volume found in Classical paintings is here replaced by a flat area of colour. This is indeed the juncture where all the elements present in the painting begin to come together to form a decorative whole. Renaissance perspective is ultimately not ignored — it remains to give a three-dimensional aspect to the work, like all the real volumes subordinated to the flatness.

Also present in this compositional play is the calligraphic beauty of Eastern miniatures. All the depiction of individual features like the pattern on the wallpaper and the dresses, the flowers and the design of the carpet loses its independent meaning, becoming merely one element on a colour arabesque. The painting was intended to decorate the surface of a wall and to delight the eye; it acquires value not as an imitation of real life, but as a fresh reality created by the artist.

Matisse's experience of the natural world of the East, however, made him stray away from the abstract beauty of the arabesque. He began to paint portrait-format canvases with standing figures constructed on large areas of colour. The vibrant power of the distinctive Moroccan light and colours brought the artist fresh nuances in the combination of colour surfaces: not dark blue and red, but a cold green coupled with a subdued crimson, the crossing of which unexpectedly ignites in a sunny ochre — *Moroccan Girl (Zorah Standing),* (c. 1912, Hermitage).

In the painting *The Moroccan Amido* (1911 -1912, Hermitage), there is a very little green surrounded by a pale yellow and cold pink. Matisse seems to have succeeded in capturing on canvas the particular qualities of light within shadow which he found in North African interiors — a new non-European resonance of colour correlation.

The Moroccan triptych which Morozov commissioned, is based around a dark blue which unifies all its parts, not only predominating but even determining the remaining colours. *Zorah on the Terrace* (1912, Pushkin Museum of Fine Arts), features Matisse's Moroccan model seated.

55. *Music,* 1939. Oil on canvas, 115 x 115.1 cm. Albright-Knox Gallery, Buffalo, New York.

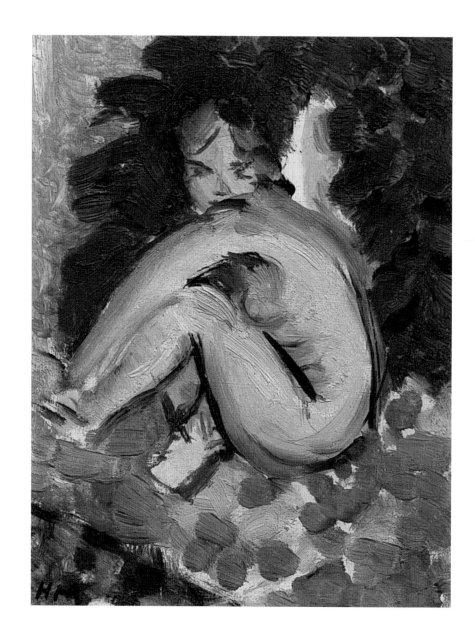

56. *Female nude sitting
(sketch),* 1935-1936.
Oil on plywood,
18 x 14 cm.
Pushkin Museum of
Fine Arts, Moscow.

57. *Pink Nude,* 1935.
Oil on canvas,
66 x 92 cm.
Baltimore Museum of
Art, Baltimore,
Maryland.

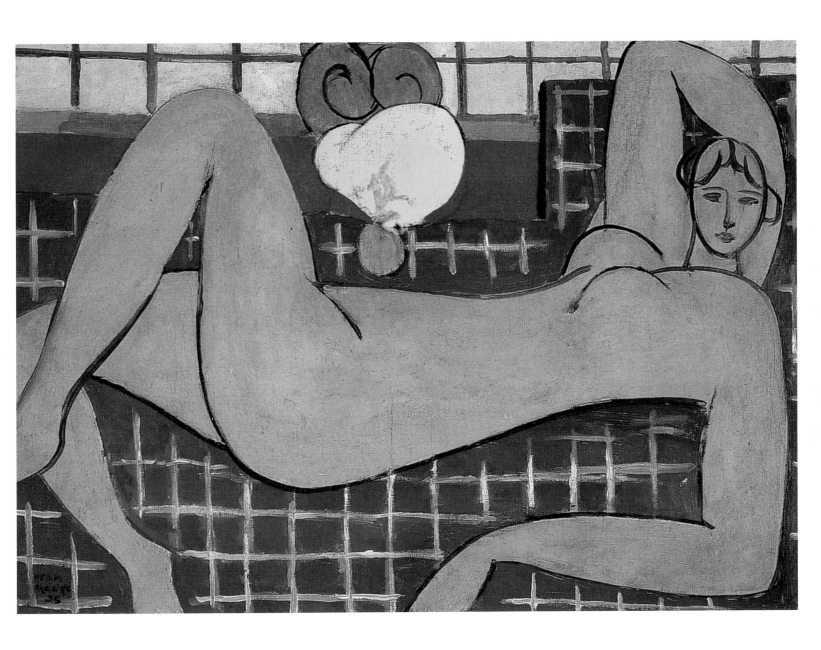

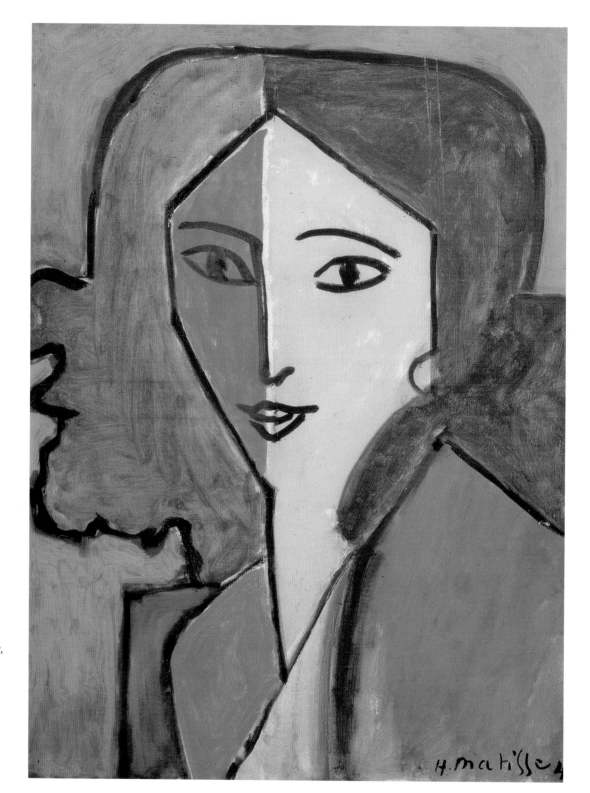

58. *Portrait of Lydia
 Delectorskaya*, 1947.
 Oil on canvas,
 64.5 x 49.5 cm.
 The State Hermitage,
 Saint-Petersburg.

59. *The Romanian Blouse,*
 1940. Oil on canvas,
 92 x 73 cm.
 National Museum of
 Modern Art, Georges
 Pompidou Centre,
 Paris.

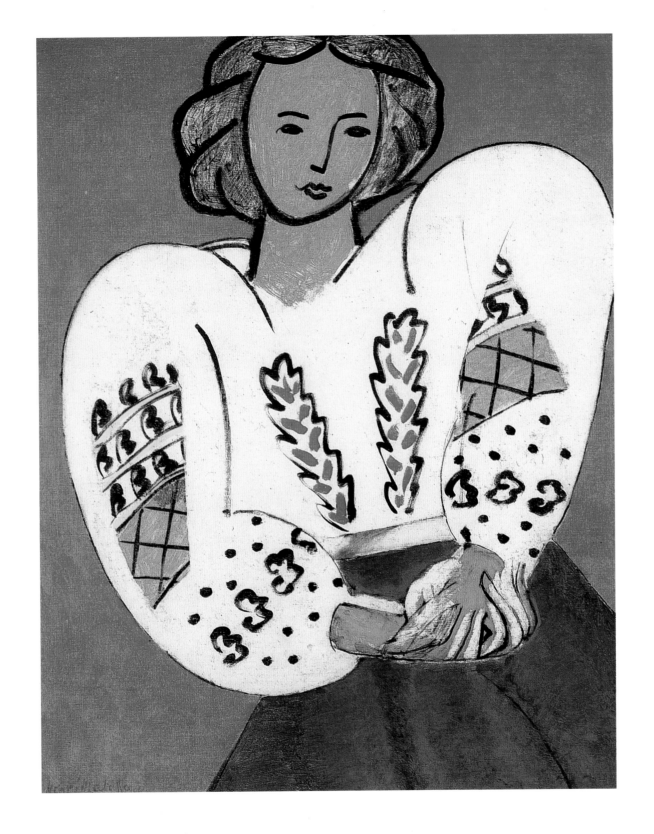

It has a generally cold feel to it, and that is broken only by three warm areas — the fish bowl, the shoes and the model's face — forming the Classical triangle that was ever present in Matisse's artistic thinking. The floor, the wall and the girl's figure make up a surface with the triangle lying in its upper part. Here the dark blue represents the cool air of the indoors, while in the flanking pictures *View from a window, Tangiers* and *Entrance to the Casbah* (both 1912, Pushkin Museum of Fine Arts) the same colour becomes the southern sky.

Yet this dark blue still did not satisfy Matisse and the painting *Arab coffee house* (1913, Hermitage), which is considered to be one of his Eastern masterpieces, shows that his search for an optimal resolution was never ending.

In *Music* and *The Dance* Matisse limited himself to three colours. He found a new harmony: a turquoise-green, softening the blue almost to the point where it gives a physical sensation of cool shadow, a silvery grey and, finally, a dense yellow ochre.

In April 1913 Matisse exhibited eleven Moroccan works at the Galerie Bernheim-Jeune in Paris. After visiting Matisse's studio and seeing the as yet unfinished *Arab coffee house* the critic Sembat spoke of the clothes being painted in bright red, dark blue and yellow, describing the work as abundant with details such as the shoes, pipes and carefully drawn facial features. The finished work shows how Matisse abandoned variety and "verbosity", how he strove to exorcise detail and harmonize and generalize the colours. Later too, throughout his entire remaining career, Matisse pursued artistic perfection through simplification. This course brought him to a colour surface which has no further need of linear perspective: a black outline drawing of an arcade is sufficient to create perspective. Face and clothes are left without detail; a few dashes of white and an area of silver with a certain configuration suffice to ensure that every figure finds its place in space. The green background is turned into water simply by the addition of a freely drawn goldfish bowl with two ochre patches of goldfish swimming around in it.

The Matisse collections in St Petersburg and Moscow are a sufficient if not totally exhaustive representation of his pre-1914 works. They contain not only all the genres he worked in, but also the main masterworks of this period. Matisse's further creative development lies beyond the scope of the collections, with the exception of the four paintings presented by Lydia Delektorskaya. Of great value are Matisse's book illustrations and sketches from the period of the Second World War. They are examples of the artistic freedom he achieved through stubborn work, a freedom which allowed him to construct a page, a book cover or a frontispiece, with just one line or a few vibrant patches of colour. A whole lifetime divides these works from his stormy youth as a "wild beast" and yet nevertheless these works remain intrinsically a part of Fauvism. Fauvism shaped all Matisse's creative work and he himself defined it so well as: "the courage to find the purity of means."

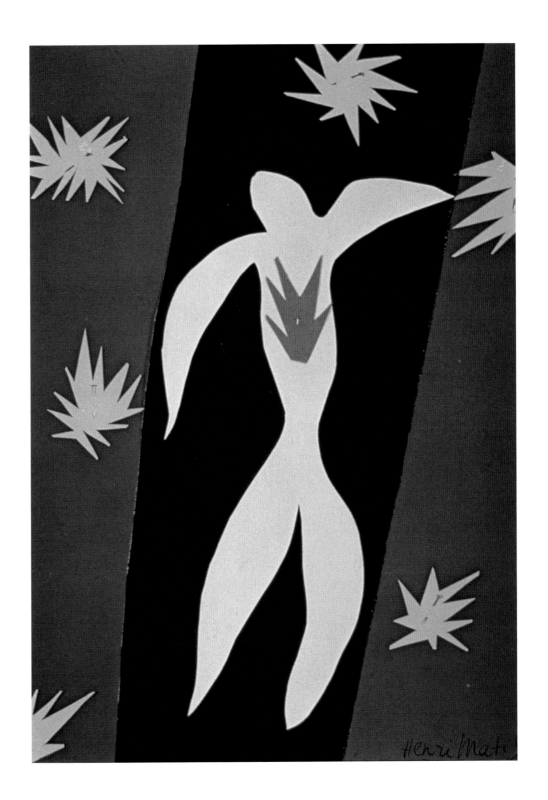

60. *The Fall of Icarus,*
1943. Paper cut-out
and pins,
34.9 x 26.7 cm.
Galerie d'Orsay,
Boston, Massachusetts.

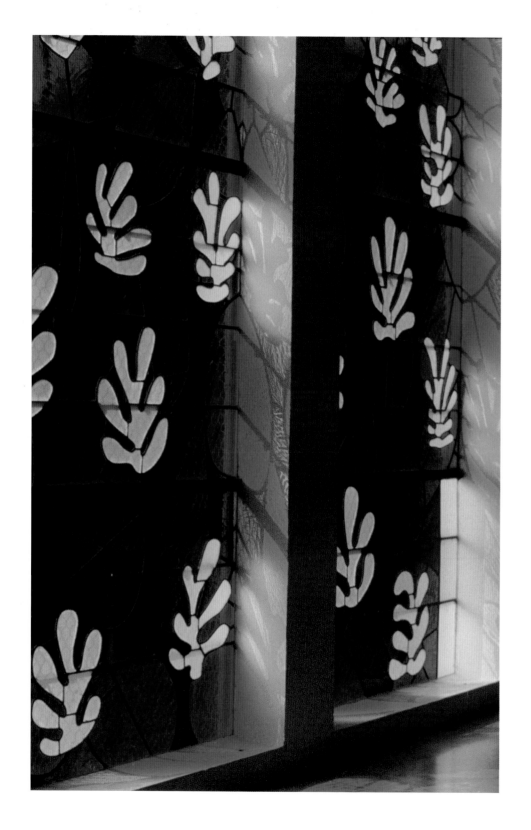

61. *Stained Glass
 Windows to the Left of
 Altar,* 1948.
 Chapel of the Rosary,
 Vence.

BIOGRAPHY

1869: Birth of Henri Emile Benoît Matisse 31st December at Cateau-Cambrésis, in the north of France. Son of a grain merchant, he is destined to succeed him as head of his business.

1887-1889: He studies law in Paris

1889: He works as a solicitor's clerk in Saint-Quentin Case.

1890: He begins to paint during a consecutive period of rest due to an appendix operation.

1892: He goes regularly to the Julian Academy for the academic painting professeur William Bouguereau (1825-1905).

1895: He follows lessons by Gustave Moreau at the school of Fine Art. He copies works of the academic tradition. He meets Albert Marquet, Georges Rouault, Charles Camoin, Henri Manguin.

1894: Birth of his daughter Maguerite.

1898: He marries Amélie Parayre, mother of his daughter. Following this, two other children are born of this marriage: Jean (1899) and Pierre (1900). He makes a short journey to London to contemplate the works of English painter Turner (1775-1851). He leaves for Corsica: his first contact with the Mediterranean.

1899: He leaves the school of Fine Arts after the death of Gustave Moreau. In Febuary, he settles himself in 19 quai Saint-Michel, until 1907.

1900: He works with Marquet in the decoration of the Grand Palais for the Universal Exposition.

1901: He has an exhibition at the Salon des Indépendants and at the Rétrospective van Gogh with Bernheim-Jeune. Derain introduces Maurice de Vlaminck to him.

1904: In June he has an exhibition with the celebrated merchant Vollard. He passes the summer at Saint-Tropez with Paul Signac where he practices divisionism, in the company of the above and that of Henri-Edmond Cross.

1905: He has an exhibition: *Luxe, calme et volupté*. He spends the summer at Collioure where he rejoins Derain. He visits Aristide Maillol. He has an exhibition at the Salon d'Automne. The critic Louis Vauxcelles calls the exhibition hall of these artists the 'cage of the wild'.

62. *Pale blue window (Stained Glass Window in the Chapel of the Rosary, Venice)*, 1948-1949. Gouache and paper cut-out, pasted on wrapping paper and strong white paper, transposed on canvas, 515 x 252 cm. Two parts. National Museum of Modern Art, Georges Pompidou Centre, Paris.

63. *The King's sadness*, 1952. Oil on canvas, 386 x 292 cm. National Museum of Modern Art, Georges Pompidou Centre, Paris.

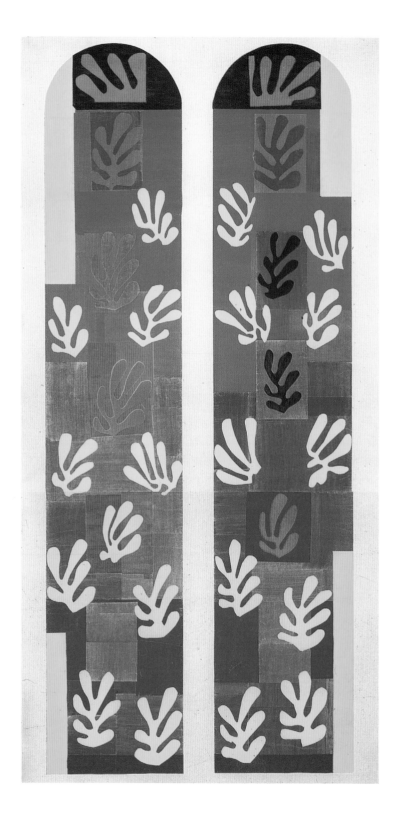

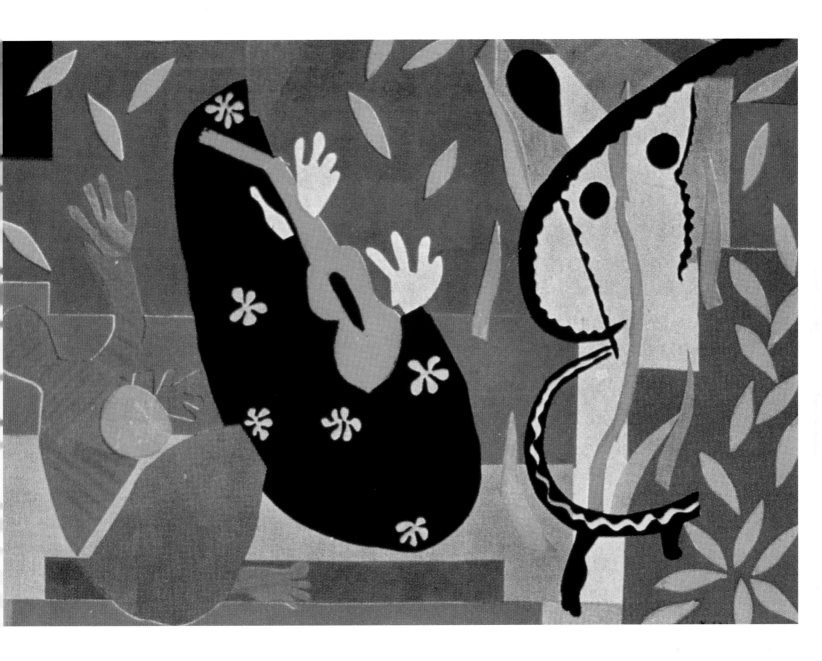

1906:	He paints *Joie de vivre*. He begins to find negro art interesting.
1907:	Rétrospective Cézanne at the Salon d'Automne. He meets Pablo Picasso.
1908:	He receives an order from a Russian collector, Serguei Chtchoukine, for wall panelling on the theme of dance and music, both achieved in 1911. He opens an academy in his Parisian studio, rue de Sèvres.
1910:	He visits the Muslim art exhibition in Munich with Marquet.
1910-1911:	He spends winter in southern Spain.
1912-1913:	He makes several journeys to Morocco. The *Triptyque marocain* is acquired by Serguei Morosov.
1914:	He returns to his studio at 19 quai Saint-Michel in Paris.
1920:	He designs the scenery and costumes for *rossignol* by Igor Stravinsky, the Russian ballet of Diaghilev.
1921:	He moves to Nice.
1930:	He travels to Tahiti whilst passing through New York and San Francisco. In the Autumn, he takes his place on the jury for the Carnegie Institute's international exhibition in Pittsburgh. He then goes to Merion (Pennsylvania) where Doctor Barnes asks him to paint a mural on the theme of dance, this second version is inaugurated in 1933.
1932:	He engraves the illustrations of Mallarmé's *Poems* for Albert Skira.
1935:	He paints *Fenêtre à Tahiti*, tapestry woven at Beauvais for Madame Cuttoli.
1938:	He moves to Cimiez. He designs the scenery and costumes for *Rouges et Noir*, choreographed by Massine, for the Russian ballet of Monte Carlo.
1941:	He illustrates Montherlant's *Pasiphaé* and Ronsard's *Florilège des œuvres*.
1942 :	He illustrates Charles d'Orléans' *Poèmes*. He uses for the first time gouache and torn paper.
1943:	He moves to Venice.
1945:	Retrospection of his work at the Salon d'Automne.
1947:	Publication of twenty *Jazz* gouaches.
1948-1954:	He works on changing and decorating the Dominican chapel in Venice.
1949:	First torn paperwork.
1950-1954:	He makes a series of cut gouache, like the *Nus bleus*.
1952:	Inauguration of the Matisse Museum at Cateau.
1954:	3rd November Matisse dies in Nice.

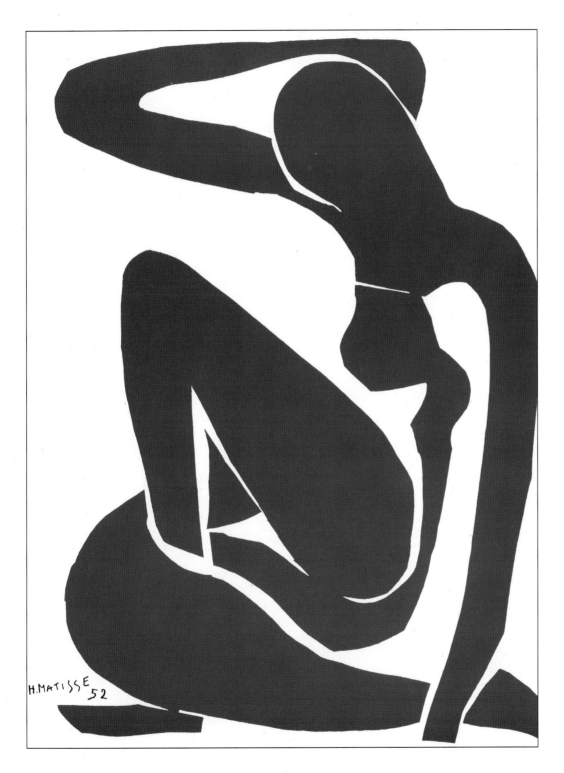

64. *Nu Bleu I,* 1952.
Colour pochoir.
Beyeler Foundation
Collection, Basel.

LIST OF ILLUSTRATIONS